Raring to Go!

More Biographies from Veloce:

A Chequered Life – Graham Warner and the Chequered Flag (Heseltine)

Amédée Gordini ... a true racing legend (Smith)

André Lefebvre, and the cars he created at Voisin and Citroën (Beck)

Bunty – Remembering a gentleman of noble Scottish-Irish descent (Schrader)

Chris Carter at Large – Stories from a lifetime in motorcycle racing (Carter & Skelton)

Cliff Allison, The Official Biography of – From the Fells to Ferrari (Gauld)

Edward Turner – The Man Behind the Motorcycles (Clew)

Driven by Desire – The Desiré Wilson Story (Wilson)

First Principles – The Official Biography of Keith Duckworth (Burr)

Fred Opert Story, The (Hill)

Inspired to Design – F1 cars, Indycars & racing tyres: the autobiography of Nigel Bennett (Bennett)

Jack Sears, The Official Biography of – Gentleman Jack (Gauld)

Jim Redman – Six Times World Motorcycle Champion: The Autobiography (Redman)

John Chatham – 'Mr Big Healey' – The Official Biography (Burr)

The Lee Noble Story (Wilkins)

Mason's Motoring Mayhem – Tony Mason's hectic life in motorsport and television (Mason)

Mike the Bike – Again (Macauley)

Raring to Go: Star-studded stories from high-flying reporter and sports journalist Ted Macauley (Macauley)

Raymond Mays' Magnificent Obsession (Apps)

Pat Moss Carlsson Story, The – Harnessing Horsepower (Turner)

'Sox' – Gary Hocking – the forgotten World Motorcycle Champion (Hughes)

Tom Hartley: The Dealmaker (Hartley)

Tony Robinson – The biography of a race mechanic (Wagstaff)

Virgil Exner – Visioneer: The Official Biography of Virgil M Exner Designer Extraordinaire (Grist)

www.veloce.co.uk

First published in March 2022 by Veloce Publishing Limited, Veloce House, Parkway Farm Business Park, Middle Farm Way, Poundbury, Dorchester DT1 3AR, England. Tel +44 (0)1305 260068 / Fax 01305 250479 / e-mail info@ veloce.co.uk / web www.veloce.co.uk or www.velocebooks.com.
ISBN: 978-1-787116-71-9; UPC: 6-36847-01671-5.

Raring To Go!

Star-studded stories from high-flying
reporter and sports journalist
Ted Macauley

VELOCE PUBLISHING
THE PUBLISHER OF FINE AUTOMOTIVE BOOKS

Contents

Introduction and thanks

It is hard to believe that many other people have revelled in such a long, and wide and varied career as I have over fifty-odd years. And it has not yet stopped, evidenced by this humble and ongoing recollection of my treasured time in the public eye on a global stage.

It all began shortly after I was demobbed from my two-year National Service in the Royal Air Force, after turning down the opportunity of a flying commission with Bomber Command, offered with six months to go before I got back to Civvy Street. Two days after my release, with my uniform binned, I joined the *Daily Express* in Manchester as a reporter, taking up where I left off from my earlier teenage training days with the now-defunct *Daily Despatch* and *Manchester Evening Chronicle*.

One year later I was persuaded by Maurice Wigglesworth, the 25-stone news editor, to switch to the *Daily Mirror*, with overtime at the *Sunday Mirror*. Double wages! And expenses! Wow! It was the exciting start of a fascinating and absorbing career with coverage of wars, murders, dramas, meetings with globally famous movie stars, months in Hollywood, sporting heroes, many of whom, from all aspects, remain as friends to this day.

The job also – thankfully – paved the way for me to meet my lovely and treasured wife Delia in Japan. She was living

and working there when I was sent to Tokyo to cover the Grand Prix. We fell for each other right away and were married on her return to the UK.

I like to think these memoirs provide a personal close-up of some of the 'world renowned' – in all capacities – who usually reveal little about their private selves and just want to get on with careers and business. But as so many have opened up for me it has made the book not so much an autobiography as a rare and unique visit to the inner sanctums of some of those exceptional people I have been privileged to know.

My career has been divided into three distinct parts, all definitive, and now bringing fresh light to the dim and distant past. Firstly, my duties as a news reporter, then as a feature writer and, finally, a sports specialist and columnist. These duties have brought into my life the unbeatable likes of movie stars Lee Marvin, Paul Newman, Jayne Mansfield, Michael Caine, Ringo Starr, soccer heroes Sir Matt Busby, Malcolm Allison, George Best and Bobby Charlton ... and many, many more from just about every walk of life.

Another offshoot of sports reporting included a spell of management. Roger Burnett and Rob McElnea, two superstar motorcycle riders, were good friends who I met when I was covering Grand Prix bike racing for *The Mirror* in the UK as well as a list of mags and newspapers abroad. They both asked me to be their manager and I was only too honoured to be trusted with their top secret dreams and ambitions. I adopted the 'alias' Ian Ley (my middle name and the last three letters of my surname) to enable me to reach fresh markets as a newcomer, and, in so doing, the wider international scene really opened up for my regular stories and features.

It would be unforgivably remiss of me not to single out my very best friend, the motorbike race genius, Mike Hailwood, the multi-multi-millionaire's son, who could have led a

comfortably cosy untroubled way of life born into vast riches with a doting dad, but he chose instead to risk life and limb on two wheels around the world's most dangerous circuits, mainly the Isle of Man TT, where he became the all-time legend. He put me firmly in the motorsport spotlight. Thank you, Mike!

I must also include here a fond memory of a truly great friend, the late Ray Wilkins, who urged me for ages to write my life story. Ray and I were neighbours in a Surrey village, having first met him when he played for Manchester United and I was covering Old Trafford for *The Mirror*. It was a real treat, and a wonderful coincidence, showing how fate obliges, to discover that he and wife Jackie were living only a few yards away when I switched to the London office and relocated down south. Ray, who played for England 84 times and was captain for 10 internationals, became one of my very best friends and was a regular visitor to my home on his way to his Saturday commitments. He never stopped urging me: "You've just got to do your autobiography. Your career, and the times you have spent with the big names of sport and show business, has been the sort of life other people can only dream about."

He was still pestering me a week or so before he so tragically and prematurely died of a heart attack, aged just 61, after a fall at his home in 2018. His passing was one of the deepest sad moments of my life. I shall never forget him. I have a daily reminder ... an autographed photo of him performing for United on my office wall. My appreciation of his enthusiasm on my behalf is beyond measure. So here it is ... with a dedication to the man himself.

My final thanks go to three characters without whose help, guidance, expertise and support I could not have fulfilled my aim to pinpoint the highlights of my career, namely Adrian Ashurst, the photo expert, Andy Lessels,

a tireless expert on the verbal front, and Paul Smith, the former editorial executive on *The Mirror* – and a lifelong and treasured friend.

I am confident that well-established and renowned businesses, teams, competitors, movie stars and those behind the scenes, will be pleased to note that my memory box has not failed me. I should add that all the photos contained within these pages are from my own personal collection, many of which adorn the walls of my office and private bar at home. All those taken by other people have been given with permission to use as I wish.

I sign off with the ever-so chuffed memory of a high point: my shaven-headed appearance as an extra (unpaid), charging with scores of other soldiers across a deafeningly bomb and bullet strewn Dutch battlefield after being persuaded to take part by director Richard Attenborough, alongside Sean Connery, Gene Hackman, Tony Hopkins, Laurence Olivier, Michael Caine and Ryan O'Neal, in *A Bridge Too Far*. And that's only a part of my venturesome career ...

So, let me take you where you have never been before – behind the scenes. Read on!

Chapter 1
First report

The audience for my first ever report on a football match, forming the vague strands of the beginnings of a lifelong career covering and writing about prime soccer and global sporting events, amounted to just ... THIRTY. That was, eventually, to peak at THIRTY MILLION ...

In between times the world was my oyster – with ever more excitement to come, spiced with as tasty a set of memories and treasured moments as is possible to imagine. Most of them evidenced by photographs on the walls of my home, many of which you will find within this book. All of them extra special and the envy of my rivals in the fiercely contested international magazine and national newspaper battleground.

But let me start with an action replay, still a stark memory, of how it all began with that first ever football report while I was still at school. I had sneaked off one Wednesday afternoon to watch England thrash Wales 3-0 at Manchester City's Maine Road with legends Tommy Lawton and Wilf Mannion scoring the goals, and ensuring I had plenty to write about.

Naively, having played truant to go to the game, I wrote about it during an English composition lesson a day later. And I was ordered by my teacher, Mrs Thompson, to read the report out aloud to the assembled audience of 30 classmates. Then I was punished, as a very naughty boy who had set the wrong example, with 'lines' and detention for half-an-hour

after 4pm for a whole week as a very strict warning to any likely followers.

Decades later, after painstaking efforts and loads of sacrifices and commitments to realise my never-ending dream of being a sports writer, I was working for the *Daily Mirror* when it revelled in a mind-blowing daily readership of up to 30 million a week! It really was a wow of a time. And the sheer joy of knowing I had such an audience of potential followers was unimaginable. There could have been no greater challenge to ensure my efforts were spot-on. And I never backed off the hours and the demands imposed, often labouring well into the night and the early hours encouraged by the likes of sports editors Peter Thomas or Eric Hughes, with star award-winning writers like Frank McGhee and Derek Wallis as the finest of examples and relentless rivals for the precious and prized page space. Years later I was rewarded for my enthusiastic effort, especially in the motorsport and motorcycle grand prix fronts, with a 'Journalist of the Year' prize and a rare – very rare – Segrave Medal, presented by the Royal Automobile Club. Two honours, with memorable predecessors, beyond my wildest dreams: trophies dwelling in pride of place on my living room mantelpiece.

But let me go back in time ... a return to my growing up days in the village of Reddish, near Stockport, Cheshire. I was born in 1935, and lived with my mum, a munitions worker, and dad, an electrician and weekend pianist at his local pub, The Union. We were at 43 David Street, Grandma lived at 47, and close friends the Morris family at 45. The local glamour girls, Joan Pearson, Vera Leonard and Pauline Matthews, were at the other end of the street, but my two biggest pals were Malcolm and Lawrence Reece, who lived in the posher neighbouring Ilkley Crescent.

I attended Houldsworth School, a listed building built in 1874 and still standing in 2021, around 200 yards from my weeny two-up-two-down terraced home, and just about fronting onto Houldsworth Mill, which employed hundreds of workers. The

canal that flowed behind the mill separated it from an exclusive golf club; the preserve of the better off.

My paternal grandmother, a glamorous professional chorus line dancer, persuaded her second husband, the handsome and personable Stuart Lee, third engineer on the *Queen Mary* and a WWI commanding submariner, to talk a newspaper chum into fixing me up with my first-ever job. I was taken on as a runner for the *Daily Mail* art editor, Charlie Madden, and his deputy, Bob McGowan, in the Manchester office. For some reason they took a shine to me, and eventually arranged a further education course in English Language and Lit at the Manchester College of Commerce. My keenness, excitement and deepening ambition was enhanced by accompanying photographers, and being taken out on assignments and events.

The likelihood of a successful outcome to my hopes and dreams was enhanced when I was taken on as a junior reporter by Kemsley's *Daily Dispatch*, and then, after this closed down, the *Manchester Evening Chronicle*, another goner eventually, but long after I had moved on. But it was real fun while it lasted – and I was transferred to the Wigan office, where they gave me free rein to use my own ideas to boost circulation. I did that, and it went phenomenally well, particularly when I suggested that Wigan had no pretty girls. The ensuing uproar was amazing – and we ran a beauty contest to disprove my opinion. Then I did the same in Warrington – and caused another blistering furore. But I had one contented and thankful editor as our circulation figures in the areas outstripped our main rival, the *Evening News*, and reached record highs.

Life in general was a whole deal of fun and adventure. Not very well paid, I must say, with hours of effort and concentration demanded. But my pledge to myself was to find qualification and satisfaction without disturbing those around me, family and friends, privileged as I have been to dwell on a world stage over half a century of living life to the full.

Chapter 2

Treasured moments:
from the Far East to the South East

I shall be forever indebted to the precious and treasured moments I spent in sport on a worldwide scale – but none more so than an extra special, unique and unforgettable occurrence that occupies my thoughts and fond recollections to this day. And always will ...

The scene was a private room in the famous century-old characteristic Toriyaso restaurant in Chuo-Ku, Tokyo, Japan. The date: Friday March 25, 1987. The time: 7pm. My companions: Rothmans cigarette company bosses Sean Roberts and John Newcombe. The occasion: a dinner to hail the company's backing, along with Honda, of motorbike ace and TT star Roger Burnett, whom I managed, ahead of the Japanese Grand Prix.

For years, being a nervous flyer, I had resisted the far-off wearisome and tiring travelling distances like those imposed by Japan. But my commitment to Burnett and duties to Rothmans who had funded my first-class jet flight from London and a stay in the very ritziest hotels, meant that this time around I had no choice but to go. Fate often plays the most astonishing and rewarding tricks. As it did for me ... with a truly amazing and breath-taking outcome. At spot-on 7pm, Burnett strode into the private dining suite headed by an eye-catching blue-eyed blonde, perfectly petitely-shaped, and stylishly dressed. Her name: Delia. My wife to be ... Astonishingly, even though

I had been round the block a good few times, it was love at first sight for me – and her, too, as she revealed to me after we had eventually set up a long distance letter-writing and phone-calling relationship. The daughter of a successful tycoon of a father with vast home county property interests and investments, she had been living in Tokyo, working in PR for Rothmans, for seven years without any special or urgent yearnings to return to her Surrey origins and delightful siblings – three brothers and two sisters – in the UK.

I could not wait to get back to Japan to see her again – and a year later, after our spaced-out but oh-so-sincere courtship, I was assigned by *The Mirror* to cover the Japanese Grand Prix, and, while there, to report on pop idol Mick Jagger's first solo concert as well as the world heavyweight boxing clash between formidable champion Mike Tyson – not a very likeable chap – and challenger Tony Tubbs, all of whom I met for interviews. But, far more importantly for me, I was able to convey my affection for Delia and impress upon her the need for her to come back to the UK so we could take our relationship towards a finite and permanent result: wedded bliss! Along the way, in the progressive build-up to the crucial title fight, I was introduced ringside to Cassius Clay ... Muhammad Ali ... and renowned crooner Andy Williams who was presenting the brawl.

Years later Williams and I met again in London, and he recalled our get-together in Tokyo, laughingly saying: "You certainly stopped some vodka going bad." And "Whatever happened to the blonde lady?" "We got married in Italy," I answered. As indeed we had, on September 2, 2003, in Bellagio, the picturesque water's-edge village with spectacular mountain views on the opposite side of deep and dark Lake Como.

Our honeymoon was spent at the magnificently regal Grand Hotel Villa Serbelloni, my favourite long-time stopover on the outskirts of Milan when I covered Italian Formula One championship races at Monza, an hour's drive away. We return

every year to celebrate that magic afternoon when we were wed by the tiny township's registrar; each visit remembered and signified by me with a dated Tiffany heart for Delia's silver bracelet, and presented over a gourmet champagne dinner in the sumptuous, five-star restaurant. The manager, Antonio, painstakingly organised our wedding and a garden reception, making all the arrangements, and ensuring we had the romantic lakeside-view suite for our honeymoon night and the rest of the week. We were driven home to England by our special wedding guests, and long-time friends and party-goers par excellence, estate agent and property developer, Roy James Fancy and his wife, Sandra, in their drop-top Rolls-Royce, and gourmandising just about every furlong of the three-day return venture.

Delia (Dee to me and her close friends) inherited her father Jim's shrewd business acumen, and she opened a double-fronted, ladies fashion boutique in the High Street in wealth-belt Cobham. The village lies 25 miles from the capital and is centred in a zone known as the UK Beverly Hills due to its overflow of residential moneybags, London-based mainstream businessmen and private jet-setting international traders in their multi-million-pound mansions. The shop has become a stop-over for a host of glamorous fashion icons.

The intense demands of fashion-seeking ladies did not stop Delia joining me on some Grand Prix jaunts to far distant locations in Australia, back in Japan, Europe and South America. Some of the most memorable and glorious occasions were spent aboard harbour-side yachts in Monaco with team chiefs and star celebrities, all household names, and Formula One's genius of an organiser Bernie Ecclestone, who developed into the firmest and most valued of friends over the years. We covered many of the European trips in our ever-changing and shared passion for speedsters, a collection of upper-class motors ... my succession of three E-type Jaguars, one of them a convertible, and an eye-catching traffic-stopper, a scarlet Iso Griffo Italian

supercar, a real gawper's delight, as well as Dee's various two-seater Porsches. I had no qualms about her driving – she had been doing so since her father let her loose either in his Jaguar limo or his Rolls-Royce when she was just 18.

I moved down from Manchester to Surrey, and we set up home not too far from Sandown Park race course in Esher before switching to nearby Cobham, with its gentle stream-like River Mole flowing through the ever-so-green and attractive surroundings flanking its busy main street. Chelsea football club opened its new training ground just two miles from our quaint, white-washed 100-year-old cottage, once the servants' quarters, at the far reaches of a colourful garden to a huge mansion that has since been demolished and replaced by a couple of vast, multi-bedroomed showcase houses with eye-watering price tags. One of these is occupied by the owner of a colourful and ear-splittingly rowdy Maserati that is our regular dawn wake-up call.

The place then for tasty, value-for-money nosh-ups – and still is to my reckoning – was the smartly and efficiently organised Good Earth Chinese restaurant, adjoining Sandown Park, two minutes' walk away, and miles from mediocrity. Thanks to long-term manager Eric, who has become a firm and welcoming friend. The entire area – Esher, Cobham, Oxshott, Weybridge and St George's estate – is still a stamping ground for the wealthy and famous, with, historically living there, Beatles George Harrison and John Lennon, Hollywood movie star Antonio Banderas, Tommy Steele, footballers Graeme La Saux and John Terry. And, of course, my best friend, the late Ray Wilkins, the gifted Chelsea play-maker and England captain, a neighbour just a few doors distant, a regular breakfast, brunch, lunch, afternoon tea, supper and dinner guest at Chez-Macauley and an absolute treat every moment. Now a treasured memory.

Chapter 3
Kerris and Iain: recollections

When I let them know I was writing my memoirs, my two kids, Iain and his younger sister Kerris, were both stirred to recalls from their growing-up days in our century-old farmhouse home, just outside Manchester in a sparsely inhabited country lane with two cosy pubs, memorable views of the spectacular Pennines, and happy-go-lucky, party-throwing neighbours Nigel and Nancy Crossley, who were only too ready, when I was pressed for time, to organise on my behalf rare-wine dinner parties that at times lasted the whole night with dawn departures and multiple hangovers.

The following wordage from each of my children is a rewarding reminder of times and high points, some of which I had long since forgotten – revelations about what they were thinking while I was getting on with my journalistic duties on the *Daily Express* and then the *Daily Mirror*, and building up friendships and contacts on both a professional and private front.

KERRIS
"I can remember one special day when an impressive van with Yamaha decorations pulled its way onto our drive at Big House Farm one sunny Saturday afternoon. It revealed a treat. Off the back of Dad's book, The Yamaha Legend, the Japanese motorbike giants had sent their grateful thank-you reward in the shape of

a monkey-bike. The funny little bike was all in bits which made it something of a puzzle to my non-mechanically minded father – but a challenge to the family, Iain in particular, and out came the redundant spanners. And so began a year or so of my 6ft 2in daddy scooting in all sorts of weather miles down the road on the mini-wheeled uncomfortable 50cc bike to collect his daily pile of newspapers and magazines. It also fired up big brother Iain's interests in motorbikes, that has lasted to the present day, evidenced by his collection of 1000cc versions."

Kerris, and husband Mark, mum and dad to daughter Fi-Fi Storm and brother Max, enjoy yachting in their own boat and horse riding – that is, when she is not commuting to London on business and he is not behind the counter or in the workshop of his cycle sales showroom in Cambridge, ten miles from their rural home and its houseful of pet dogs.

"Dad, as long as I can remember, always loved entertaining and hosting vibrant, atmospheric dinner parties or simple booze-ups which were held pretty much on a weekly basis. The varied mixture of fascinating guests included wonderfully interesting newspapermen. His colleagues, who were always full of fascinating stories and secrets, like Leo White, the Mirror's Yorkshire-born news editor, and his missus Lizzy, who just about everybody loved. They were a magic couple. Kindness and consideration personified.

"The house was hardly ever not teeming with party-goers and recognisably world famous faces ... the likes of Man United football legends Bobby Charlton and George Best, and England striker heroes Mike Summerbee and Franny Lee along with their Manchester City manager playboy and inexhaustible nightlong boozer, the handsome and stylish trilby-hatted and fur-coated Malcolm Allison. All of them were invited by Dad to scrawl a message and their autograph on the ceiling of the well-stocked bar, the replica of an Irish pub complete with a one-armed bandit,

pinball, darts board, pews rescued from a nearby church clear out, and optics, with photos of the famed visitors plastered on every available white-walled space.

"One early evening in the '80s there was a ring on the doorbell. I answered the door, and standing there, to my utter astonishment was the Hollywood actor Ian McShane and his beautiful wife Gwen Humble. Ian was disguisedly wearing a pulled down flat cap and high-collared tweed jacket, Gwen was spectacularly clad in furs and stiletto heels, looking every shapely inch the famed ideally neat and elegantly presented looker she really was. Off they traipsed with Mum and Dad for pre-dinner beers and gin-and-tonics at our local pub, the very down to earth and well attended boozer, The Farmer's Arms, a few yards distant from our front door, with its personal tankards draped over the bar, as a gang of thirsty local farmers, up at 4am, swigged pints of ale with rum chasers. Amidst them, unrecognised, or at least untroubled, was Judas Iscariot, alias McShane, downing pints in our village local with his traffic-stopper wife, the runner-up of Miss USA, plus my parents.

"There was one stand-out and famous figure in noticeable attendance at every party – actually every day. It was a life-size fibreglass model of world motorcycle champion, America's idol Kenny Roberts, fully attired in team leathers on his permanent seat at the far end of a pew in the bar. I think Dad had been presented with it on one of his GP trips – but I do know he bought the dummy its own passenger seat when he flew back with it from the USA.

"Dad was a firmly committed Manchester United fan, and a constant companion to megastars Bobby Charlton and George Best, never at the same time, because even though they were teammates they were never the best of friends. When United played Liverpool in the 1977 FA Cup Final, Dad was given complimentary tickets by the Old Trafford hierarchy, the Scousers, and the FA – and he opted for the Liverpool issues that gave Mum and Dad the very, very best view as they sat very quietly among masses of fanatical

Anfield supporters without daring to yell their backing for United, tough as it was to keep quiet.

"When he covered motorsport, one of his – and our – favourite experiences was to attend Donington Park, centred in the Midlands, owned and expertly run by self-made millionaire Tom Wheatcroft who became a strong and long-lasting friend. So much so, that whenever we attended a race, bikes or cars, he invited us into Uncle Tom's Cabin, his private two-storey box, right over the track, with its own bar and serving staff. I can remember pitching up for the massively attended and exciting Trans-Atlantic Challenge motorbike set-to. I was a teenager with a couple of friends – and Tom waved to me and them from his balcony to join him. Just because I was my dad's daughter! Already there, and offering the warmest of greetings, was one of Dad's oldest chums, legendary broadcaster Murray Walker and his marvellously friendly but reserved wife Elizabeth. I lost count of the team bosses all noshing at Tom's generous expense.

"I can honestly say that my brother Iain and I had an amazing, exciting and memorable childhood, travelling worldwide to incredible places, like staying at renowned author Ernest Hemingway's Bahamian house and the Hollywood duplex owned by Isle of Man-based Trevor Baines, organiser of the Miss World competition.

"But there was a dark time, too. I shall never forget it. I was aged eight and I woke up one morning to see an ambulance taking my dad to hospital in a dire and worrying emergency, suffering a heart attack. He was just 38 – and made a remarkable recovery. During his inevitable lay-off The Mirror was brilliantly thoughtful and touchingly considerate. They offered to send the family anywhere he fancied to help him recuperate and speed up his recovery. So where did we opt for? The Caribbean? The Indian Ocean? Sunny Australia? No, Dad wanted to follow at his own leisure and pace the Moto GP battle around Europe. And, based in Capri at The Mirror's cost, we did our to-ing-and fro-ing for six weeks on the near continent."

IAIN

Over to my son Iain, Kerris' senior by two years, a very clever and talented artist as well as a writer of clarity and purpose. He emerged from his early training as a reporter on the *Warrington Guardian*, Lancashire, to freelance for the nationals before establishing himself with a PR and publicity set-up that was a mix of showbiz and sport – and with frequent Parliamentary attendances to look after a couple of MPs. In between times, affected and entranced by his fascination for speed, he raced ... secretly ... in countrywide single-seater events. He told his Canadian wife Pam that he was working on projects that made demands on his weekend. An issue she readily accepted as she busied herself establishing a gift shop business in Altrincham near their Cheshire countryside home ten miles from Manchester's Piccadilly city centre. Then, one weekend, she said she would like to take time off, relax and share one of Iain's weekend away jobs. And that's when he had to confess he was in secret a car racer with a season-long commitment. I didn't know either, nor did Kerris, that he was regularly sticking his neck out in the hectic hurly-burly and costly pastime of car racing. Not long after, he packed it all in and swapped to jaunts up and down the country on his massively powerful motorbikes.

Iain, proud father of two clever children, son Ben and daughter Charlotte, both of them now with university degrees, recalls:

"My first recollection, when I first became curious about what Dad did for a living, was thinking that he worked in a newsagents' shop. I was aged about seven before I realised that it was his name on pages of the Daily Mirror when it dropped regularly through the door where we lived in Whitefield, just outside Manchester.

"He first started taking me with him on jobs when I was about eight or nine years old. And my first memory was going to a

Manchester United match one evening. We were standing just inside the players' entrance at Old Trafford when all of these heroic figures walked past us with the majority of them saying hello to him and some of them greeting me, too. It was unreal. And right up to now I have a mind's eye image of George Best, Bobby Charlton and Denis Law, all world-famous internationals, framed in the doorway of their lounge. I can remember that United had thrashed QPR 8-1 a few days earlier in 1969, and I expected every game to be like that. But I recall one foggy, damp and freezing Monday night match against Stoke City finishing up one-each.

"With hindsight I now realise Dad's name and reputation rescued me from trouble on quite a few occasions. Some of the teachers at my Stand Grammar School considered him quite famous, probably because of his widely publicised association with some of the biggest and famed names in both sport and news – and so, inevitably, they perhaps considered me to be a wee bit too risky to deploy. At school in my teens I just thought Dad spent his life and leisure with remarkably amusing, enjoyable, funny people and famous personalities on a global scale. Most Saturdays I would arrive home from whatever I had been up to and see an unfamiliar car on the drive, or a private cab arriving or leaving. They included Bobby Charlton's yellow Mustang, part of a promotional contract with Ford, arranged by Dad, or George Best's E-type, bought by the Irish superstar on Dad's advice. Or I would open the front door to find rising movie star Ian McShane, or the son of Manchester United's Scottish-born executive Harry, the voice of The Reds as the brainchild of the United Old Boys Association, glamorous actress Gayle Hunnicutt, and a host of well-knowns, all happy to empty Dad's liquor loaded private bar, and just be fun and relaxed away from their daily pressures.

"When I grew up, and was included in the get-togethers, I would experience the funniest, happiest and most educational soirées, with stand-up chat swapping, and never stopping amid a mass of end-of-dinner stories involving what could have otherwise been valued

national newspaper scoops – but which never made it beyond our bar or dining table because Dad accepted he was among special and highly regarded friends who were being supremely confidential, not looking for publicity, and who trusted him implicitly. He drew a line between his incident-and-info packed social life and his professional responsibilities. He always insisted to his guests: 'Don't tell me any secrets you don't trust me to keep within these walls.'

"In company with a very over-worked, but totally happy and satisfied father, I went to all manner of top-level sports events from Manchester United's European clashes and home front battles against the likes of Manchester City and hot rivals Liverpool – but, the biggest treats of all for me were the trips to the motorcycle Grand Prix classics around Europe, often with 100,000-plus spectators in traffic-jams galore. And they led to my dream of a meeting, and resultant long-standing friendship, with the runaway, record-breaking Italian genius on two wheels, Giacomo 'Mino' Agostini. When we, me and Kerris, were first introduced to him in Belgium we posed for a photograph with him. As he stood on the elevated kerb he nudged me and Kerris into the gutter so we were not looking any taller than him. He was a truly admirable and modest man despite his film star handsomeness, a delight to be with, and a daredevil gifted talent almost beyond belief on two wheels. Amazingly, 45 years on, he picked me out of a crowd at Silverstone to give me a warm hug and the concerned question: "How's your pappa?"

"Another true great was Mike Hailwood, Dad's best friend, who set both the motorcycle grand prix world and F1 alight with his ability and dedication to hold onto a winning streak whatever the odds. I spent a weekend at Silverstone with him and Dad and motorsport California-based UK entrepreneurs and race organisers Gavin Trippe and Bruce Cox. To this day I can never forget the weekend. Quite what the staff at the Boots store in nearby Northampton thought was anybody's guess, when the four of us,

accompanied by a volunteer policeman happily in tow, dropped in to buy flat caps that we had decided were in fashion. Dinners at our hotel on the Friday and Saturday were riotous and boozy, a special show, so much so, and so infectious that other diners jostled to join in. I laughed so much I was knackered come Monday and, back home, I had to work out in the gym to restore some sort of recovery.

"I cannot recall making a conscious choice to follow Dad into journalism – it just seemed to be an automatically inherited outcome. Truth to tell, when it happened and I was in fullish flow, it was one heck of a shock with a mountain of mixed experiences, good, bad and indifferent. But never ever boring.

"Dad decided to plunge me in at the deep end by getting me to cover lower league football for the Sunday Mirror – long before I had even got my A-level result – and then later blagged me into writing match reports about Manchester United, Manchester City, Liverpool and Everton for an Irish paper he had been serving on the QT. He also steered me into foreign fields, with several assignments in Europe and then Miami, Dubai and the former battlefields of France, on a freelance basis. It was mostly weekend stuff – and along the way I made friends with the oddball Liverpool goalkeeper Bruce Grobbelaar.

"The weekday work was more of a shock, and I found it difficult to get off a plane or step out of the mainstream football circle to write about the local Rotary Club, or non-league soccer, town council meetings or civic celebrations, for my local Bury or Burnley weekly newspapers. The overlap between my weekly paper duties and international travel on behalf of Dad was both bewildering and exciting beyond measure, and it all served to underpin my aims to follow in Dad's footsteps in his fabulous national and international newspaper and magazine career.

"One day, when I was writing for the Warrington Guardian, surrounded by nearly 30 people in the newsroom, I heard one of the editorial doors open but didn't bother to look up from

my typewriter. But I did when a figure loomed over me. It was Bobby Charlton, and with everybody gawping open-mouthed at the world-renowned footballer, he greeted me with a handshake saying: "Hello, Iain, how are you?" Never mind my being a reporter on a weekly newspaper, I should have been in acting as I attempted to nonchalantly shrug off Bobby's presence as a norm, while everybody within earshot stopped what they were doing to take in the significant and surprise appearance of the Manchester United and England footballer.

"One day when I was at work, Dad phoned to invite me to join him for lunch in his favourite Manchester pub, but I was so tied-up in meetings I couldn't make it. 'What a bloody shame,' he retorted, 'I am here with George Best and Alex Higgins and we are having a great laugh.'

"More recently, not too long before he died, Ray Wilkins, former Manchester United and Chelsea star, a neighbour and Dad's best friend, answered the front door to me at the Macauley dwelling, having popped round and let himself in while Dad was out. That's the way it has always been. Dad's lifestyle has never changed or faltered and it has been a real treat to watch it all develop and to have a memory box jammed with unforgettable happenings and endless hours with the fast, furious and famous."

Chapter 4
The high life

There have been so many memorable high points over the years, shared with generous and kindly benefactors hell-bent on ensuring they guaranteed me and my wife Delia's utter joy, stemming from my career and overspilling into my private life, that it is almost impossible to recount them all. But anyway, here goes, in no particular order and with no special preference.

The eight-seater private jet soared into the wide blue yonder, carrying me and Delia to Marseilles airport. A couple of hours later, having reduced the stock of Moët & Chandon, we were awaiting our baggage when a smartly uniformed, well-spoken chap approached us with: "Excuse me ... are you Mr and Mrs Macauley? Mr Lamprell has sent me to take you to his yacht. My helicopter is just over there ..."

Wow! Steve Lamprell, a mega-wealthy and highly successful businessman with a vast oil rig building business in Dubai, was awaiting our arrival aboard his yacht when, after a sightseeing treat over Monaco, we descended smoothly onto a helicopter pad on an elevated patch on the deck a few metres from where our host was standing holding a bottle of bubbly.

We had met Steve and his wife Gillie on a visit to Dubai a decade earlier ... and this time around he was, he said, repaying a debt to me for what he called one of the great weeks of his life. His chairman, Peter Whitbread, had asked me if I could do him a big favour and arrange for somebody well known, either

in sport or showbiz, to guest and speak at an annual celebration dinner which he was hosting for a horde of VIP guests in Dubai. I took George Best ...

We travelled out together, but George's obvious poor health at the time, and some 'incidents' on the trip, details of which will be revealed in the next chapter, had me, quite frankly, worried. But, as it turned out, I had no need to be.

George's appearance on the rostrum was a resounding success, resulting in a standing ovation: it was my dream come true. For the remainder of our stopover, with invites to the Lamprell house and Whitbread's for private lunches and dinners, George was an example of magic. A real winner.

When I returned home after our truly memorably enjoyable stay, I received a telephone call from Pete Whitbread and he said: "By way of thanks I am going to say something to you and I don't want you to interfere or interrupt until I have completed my chat. Then I just want you to say you are okay for my suggestion. Right? Here we go ... next Sunday a chauffeur driven car will collect you and Delia and take you to Farnborough airfield. There, waiting for you, will be a private jet. It will transport you to Nice. Another car will meet you at the airport and take you to Monaco where a speedboat will carry you to our yacht. From there it will cruise to the Italian coast. Then return you to Monaco where another helicopter will pick you up and transport you back to Nice for a return flight to Farnborough. Another chauffeur driven limo will return you home. It is our way of thanking you for your fixing up George Best's visit to Lamprell. What do you think? Can do?" No need to guess my response ...

And that was just one of dozens of thoroughly relaxing sailings around Europe and Croatia's magical coastline and hideaway ports and harbours on Whitbread's luxury yacht *Du Ciel* (which translates appropriately to 'Heavenly') that my wife Delia and I were treated to over a memorable ten-year spell

that only ended on Peter's tragic, too early, demise from ill-health.

So, who next? Here I make a return to Dubai. This time with legendary broadcaster Murray Walker. After another request from Lamprell for another personality to enjoy the firm's annual get-together, I persuaded Murray, a friend for years and years, to be the star attraction. His modesty, despite his fame, was a real pleasure ... and his captivating presence, again in front of scores of Lamprell connections and staff over lunch, was something I shall never forget. And yet another reward awaited me ... a cruise on *Du Ciel* around the Adriatic, with visits to the most exotic restaurants to sample their taste-bud tempting offerings washed down with the finest wines and champagne.

Here, I must feature an absolute treasure of memories citing special invitations by Steve Lamprell to join him and his wife Gillie for cruises aboard his private yacht to exotic far reaches of our planet, with just me and Delia as guests in unbelievable and exclusive luxury. Gillie took the time to detail me with their gorgeous yacht, *Itasca*, a 176-foot-long former ocean-going tugboat with teak decks and room for 12 pampered guests painstakingly and courteously cared for by a crew of 12, a captain, 1st mate, bosun, three engineers, a chef, three stewards and two deckhands. We also had a helicopter pilot living aboard. Carrying a chopper aboard opened up a new form travel for us. We were collected and delivered to and from the airports and flown to far off restaurants and places of interest which we would otherwise not have had time to visit, and all valued at around $10 million.

Gillie reminded me:

"Itasca is a treat beyond imagination ... and we would be reluctant to sell her. But having called into so many fabulous places right around world aboard her, including the Antarctic, the Galapagos

Islands, Australia, the Far East, Alaska, Svalbard and so many other exciting international destinations in exotic countries over the last 14 years, we both feel satisfied and thoroughly content with a mountain of memories.

"There are so many other places we would have liked to visit, but health conditions that hit us prohibited that dream. And Itasca served us well. She is a converted tugboat, so very safe in the roughest seas, with four double cabins, each with its own dressing area and bathroom with comfy lengthy tubs to stretch out in and wallow in comfort. We revelled in our master suite with its own study, sitting room, large galley, gym, sunbathing deck, exterior eating area, helipad and two tenders and, of course, a well-stocked bar. It was like a floating-travelling house.

"On an amazing trip to one end of the world we walked among hundreds of thousands of penguins and viewed dozens of polar bears. Breath-taking! We also swam with giant whales in the South Pacific and chewed on Cava root with chiefs of islands in the Solomon Sea.

"In the North of Norway we took a helicopter ride to land on the top of a glacier and our stewardess set up a table with canapés and pre-dinner cocktails before flying off to a restaurant for a scrumptious dinner.

"Nowadays we are little more settled and less adventurous in a gorgeous house on our own huge estate, Chadacre, in the UK. We have a busy farm and a private shoot. And we divide our time between there and a splendid home in Dubai, the scene of Steve's successful oil rig building company which he built and developed from zero with his business skills. So we are very, very happy."

While I am ambling down Memory Lane it would wrong of me not to mention three other high life events like cruising to New York, first-class, aboard the *Queen Mary 2* with most of our time spent with VIPs, dining with the charming Captain Kevin Oprey in the Britannia restaurant on deck two, or sipping cocktails with him and his officers in Stateroom 9023. Our

journey was dramatically interrupted when a crew member vanished mysteriously overboard and Captain Oprey, with apologies, turned his ship around to start a search in the rough sea. He invited passengers to be look-outs from the decks into the waves in the very faint hope the missing 25-year-old crewman might have miraculously survived. He had not ...

Then there was my thrilling flight from Paris to New York on Concorde as a guest of Air France. I stayed at the ritzy Plaza Hotel ... with yet more cocktails, in the Oak Bar, all dinner suits and eye-catching glamour girls in what looked to me like million-dollar frocks with blindingly big diamond necklaces and bracelets.

Finally, the Grand Hotel Villa Serbelloni in Bellagio, Italy, where Delia and I were wed and spent our honeymoon. It stands majestically on the banks of Lake Como with a spectacular view of a towering black mountain directly across the water from the restaurant. We still go there at least once a year, it is our very favourite stopover – the same feeling goes for the friends we have entertained at the Serbelloni – and on the weeny island, a short speedboat ride away, in the middle of the lake, an exclusive restaurant with a view to take your breath away.

Chapter 5

George Best and Barry Sheene

My coverage of global sport overlapped principally between football and grand prix racing on both two and four wheels, and brought me into the closest of contacts with two thoroughly rascally but inevitably likeable characters who remained close friends and allies right until their premature, tragic and personally heart-breaking deaths. Their names: George Best, a unique world class footballer, a memorable genius, and Barry Sheene, a stirring example of sheer bravery and excitement in the enormously risky and death-defying profession of grand prix motorcycle racing. Over all the years we spent in each other's company there was never a dull moment, and plenty of fun and frolic to keep me in a permanent state of amusement and appreciation of their very being and ceaseless antics. And from a professional standpoint they each provided me with a constant flow of writing material both on and off the football pitch and the world grand prix motor bike racing stage.

They both departed this life too soon with only a couple of years between their deaths: Barry died in 2003, aged 51, followed by a 59-year-old George in 2005, the pair of them long sufferers without complaint from self-inflicted sicknesses and setbacks triggered by their high life of late nights into early mornings, booze aplenty, strings of glamorous women, some of them international beauty contest winners, and in Barry's case too much drug taking and chain-smoking. He even had a

hole drilled in the chin guard of his crash helmet so he could puff a relaxing fag on the start-line before a race.

GEORGE

I have lost count of the number of nights George spent sleeping on the front room sofa in my quiet village farmhouse home ten miles from his Old Trafford stage. He would turn up in his E-type Jaguar, bought because he had spent time envying mine and revelled in the experience, and settle down to a glass or two of white wine, however close he was to a match, and ignoring my pleas to steer clear of the bottle. He joked: "I have spent loads of money on birds, booze and fast cars ... the rest I squandered. Then I gave up drinking and women, and it was the worst 20 minutes of my life!"

There was never a dull moment with George and you could never guess what he would be up to next. I recall being on an assignment in Majorca when I got a call from his manager Frank O'Farrell via my sports desk. George had gone missing and failed to turn up for training. O'Farrell wanted to know if I could help and I took a guess that George had skipped off to his favourite foreign haunt, Marbella, a playground for the mega-rich on the Spanish south coast. I flew there on the chance I would find him at his favoured beachside hotel. And I did! He was sitting poolside in shorts and bare-chested, beside a half empty bottle of bubbly, surrounded by a gaggle of very attentive bikini-clad beauties when I turned up. "Bloody hell, it's Ted," he laughed. "What are you doing here?"

I answered: "I've come to take you home." And he countered: "Okay, but not just yet. You can say you can't find me and we can have a couple more days relaxing. Yes?" I agreed, and enjoyed a super spell in the atmosphere he created. We flew home to be greeted by a surrounding mass of newspapermen and photographers at Manchester's Ringway airport.

In another one of his throwaway jests he said: "If you had a

choice of beating four players in a mazy dribble and smacking in a winning goal from 30 yards against, say, Liverpool, or bedding Miss World, it would be a difficult choice. Luckily I did both."

He married Angie in Las Vegas in January 1978. But it was a turbulent partnership and they divorced in 1986. Nine years later, after a run of beauties and even more booze, with long drinking sessions at the Phene Arms pub a few strides from his splendid Thameside apartment, he met and married Alex Purcey in Kensington. But they divorced in 2005 after another problematical relationship. His boozing habit was just not abating – and it resulted in a liver transplant in 2003. He also endured a debilitating lung infection. When he died in hospital in 2005 his heavy drinking habit was blamed, and he was registered as having perished from 'alcohol use disorder.' It was heart-breaking news for me – but as a consolation, shortly before he died, I was responsible for one of his final and enjoyable outings. A lasting and precious memory of a treasured friend.

As mentioned in the previous chapter, my good friend Peter Whitbread, director of Lamprell, the oil rig repair and build company in Dubai, had asked me if I knew any personality enjoying a global reputation who could come and deliver an interesting address on his or her experiences for the 50 or so international guests attending a company get-together in the United Emirates. He offered me and my wife all the hospitality we might need for a week to accompany whomsoever I could persuade to speak at a lunch. George Best came to mind instantly, and when I asked him if he fancied the trip he eagerly agreed. I had not seen him for about six months and arranged to meet at my home en route to Dubai.

His wife Alex preceded him after their four-by-four pulled onto my drive. George was still sitting in the car when she said: "He's not too well – and he may need help getting out of the

motor." I was shocked. Staggered, when, limping heavily and having trouble breathing, George struggled into my front room and virtually collapsed onto my sofa. He looked dreadful, so much so I told him he had no need to make the trip if he felt poorly. But he laughed off my suggestion and insisted we make the journey. We had been sitting in business-class waiting for take-off when the Emirates airline stewardess apologised for disturbing him but invited him and Alex to move into first class as the airline's guests. Which he did.

And the pampering did not stop there. On arrival at Dubai we were ushered through the airport and into a beautiful Bentley luxury super limo belonging to Steve Lamprell, owner of the Lamprell company, who was to host our week-long stay in suites in one of the country's most luxurious hotels. It was all a wow of a treat and it seemed to lift George back to near normal. But he did have a lapse and made such a mess of his room in a drunken spree he and Alex were switched to another. It was, mercifully, a one-off setback and for the remainder of the visit he was good manners and perfection personified. During a trip into town in the eye-catching chauffeur-driven Bentley, when we had pulled up outside a very posh restaurant, George was halfway up the stairs towards the reception area when a woman, a total stranger, holiday-making, grabbed his arm saying: "You ARE George Best aren't you? I can't believe my luck. Would you, please, please, please, come and have a photo taken with my husband and son. They are both admirers of yours." I feared he was going to explode, but before I could make excuses for him he agreed and struggled slowly back down the staircase into the sun-scorching atmosphere outside and posed on the pavement for half-a-dozen photos with the woman and her hubby and son. Then he limped back up the stairs into the restaurant saying: "She was so polite, how could I refuse her?"

A couple of days later we were entertained to lunch by Peter

Whitbread and his wife Jan – and we all went down Memory Lane. George captivated us all being intriguingly entertaining and charming. It was an endearing and encouraging session full of promise for his after-lunch speech for the Lamprell VIPs. At that special get-together the original guest list had numbered around 50. When word got out that George was the star speaker the figure doubled. I was still a wee bit worried that his weakness and tiredness might overtake him, so were Whitbread and Lamprell who both felt that if he could not go through with his speech that would be okay with them. George argued he was okay before struggling from his table to the rostrum in front of a concerned audience. But he was absolute magic. Entertaining. Funny, Informative. Revealing. Entrancing. And a total joy. He remained on his feet chatting and joking for about an hour without the slightest hint of a pause for a rest in his delivery. The room echoed with applause and a standing ovation when he made his way back to our table. And he whispered to me: "How was I? Okay?"

That he later passed away so sadly and tragically was a heartbreaker for me – and it stirred a vast response of sympathy from many of those who were lucky enough to see and enjoy his company in Dubai.

George, European Footballer of the Year in 1968, an Ireland international 37 times with nine goals, played for Manchester United 361 times and scored 137 goals. And one of them sticks out in my memory. It was against West Ham United at Old Trafford and part of a hat-trick. He crowned a majestic demonstration of his fearsome and unique ability with a goal that is forever locked safely in my memory box. And I would guarantee the same applies to just about every one of the 70,000 attenders at Old Trafford who witnessed it. It was a typical brilliant, mesmerising and exciting spectacle as he dashed, ball looking glued to his boots right across the front of the penalty area towards the West Ham goal, beating, baffling

and dodging at least half-a-dozen desperate tackles from a mass of Hammer defenders before scoring a truly memorable goal. I glanced up from my notetaking in the press box and saw Harry Redknapp, the West Ham player, dash to George's side and say something as they ran back to the centre circle for the restart. George looked aghast, paused briefly, then sprinted on for the kick-off. I wondered what it was that Redknapp had said but never discovered until about 20 years later when I found myself in Harry's company and queried him: "Do you recall that fantastic goal of George's against your lot at Old Trafford?" And he replied: "Yes, I do."

"I noticed you shouted something in his ear as you both ran back to the halfway line. What did you say?" And Harry readily recalled: "I said ... 'Magic, George, that was magic.'"

BOBBY ON BESTIE

Before he became so tragically poorly and confined to his home, my oldest and dearest friend Bobby Charlton, the England and Manchester United legend, recalled his early days with budding genius George Best, who he helped develop into the worshipped global star he became. Our interview went like this:

Sitting in the bar in my Manchester home I posed the question: "What are your personal relationships with new boy George Best?" He replied:

"It is like an old man to a young boy. In fact, now I am over thirty, I suppose I am like a veteran to him. He is only just beginning, in his early twenties, on a long and exciting career which I expect will be highly successful. Put George and me side-by-side and I suppose we could pass for father and son. If that were the case I would an extremely proud man, because he is a fantastically gifted footballer.

"Some outsiders may have the wrong impression of George. You

know how some people react when they see a fella with long hair and wearing all that gear. Well, George at times might get away with being a Carnaby Street model. That's how he looks. And very smart, too. Here is the truth about him ... He is no different from most youngsters who are crazy about football, except he is blessed with amazing talent, as gifted as can be. He may have lots of interests and diversions – his boutique for one – but there is only one real and worthwhile occupation for him: being a footballer.

"George is usually first out of the dressing room for training in the morning. And he is a devoted and committed trainer, so bloody keen, and he would shoot in and take penalties and free kicks all day long if you would let him. At United's training ground at The Cliff we have a huge covered gymnasium. George would never come out of the place if somebody would stay behind with him and play football. In the gym we often play five-a-side soccer with no throws-in or dead ball kicking. It was non-stop action and activity, flat out, giving it your all. It is like soccer squash. Just as fast and furious. It becomes really hard work if its lasts for fifteen minutes. If George has the choice it continues for an hour. That's how eager he is.

"As United's captain I have never had trouble with George on away trips or abroad. He is a thoroughly and completely dedicated professional only too happy to give it his all without advertising the fact. Sometimes you want to curse him inwardly in a match when he is trying to beat four or five opponents and he loses the ball; that is the fault of an eager young player. People probably used to curse me for the same reason when I was younger and mad keen to make my name and be a success. I have said all that about myself. With George the curses just boomerang when the things are going wrong for the team and, suddenly, with all seemingly lost, he gets the ball and starts off on one of his long, chinking and winding dribbles, beats a few men on the way, and finishes either by scoring or creating a goal for a teammate. Then you just cannot help thinking and wanting to say 'Thanks, George, for pulling us out of a hole.'

"I recall him scoring a goal in the first minute of four successive League matches. That was just the kind of start you would love to have in every match.

"When the argument comes up in the dressing rooms, restaurants and pubs in England, two names are usually the topic of conversation and mentioned in higher regard than most ... Sir Stanley Matthews and Tom Finney. I know how great they were, although I started playing at the back end of their wonderful careers. But there is no doubt in my mind that George Best can stand shoulder to shoulder with any one of the world's finest players, past and present. In fact, in today's game his control is magic, just fantastic.

"And he caps it with tremendous self confidence and belief in his own fabulous ability in action. And, on top of that, he is blessed with heroic courage. He is only too ready, willing and assuredly able to take on the toughest and most ruthless defenders on attack in the penalty area where he knows he could well get hurt. Heartless and hard-case defenders don't back off whatever your fame and reputation to ease off and tackle you as if you are a long lost brother.

"This the greatest test and demonstration of all-out courage in our game. And this is what makes George one of the very, very, best. A sure-fire certainty to go down forever more in the annals of our great game.

"There I go again, rambling on, like the proudest of fathers talking about his son. But I mean every word ..."

When George died after a reign rated as one of the world's truly most valued gifted and great footballers, although a playboy beyond imagination, he was reckoned to be worth about $250,000, a paltry sum when you compare the money pile-ups of the likes of other greats like Pele's $100m, David Beckham's $450m and Ronaldo's $90m. Can you imagine what his takings, purely from football, would have been if he had been at his prime at today's mind-boggling salaries?

BARRY

While I am talking about incomes, in stark contrast comes the final count-up of cash in Barry Sheene's money store. On his death he was reckoned to be worth around $22m, gathered in not only from his grand prix motor bike teams' wage packets but from his universal earnings as a personality much sought after for his photogenic sponsorship appeal to major international companies.

I was awakened in the early hours by a mutual friend of Barry's and mine to tell me he had passed away peacefully, surrounded by family and friends in a hospital on Australia's Queensland Gold Coast in 2003, after losing a fast deteriorating battle against the amalgam of setbacks accumulated from his wild life of madcap party-going, smoking 60 cigarettes a day, drinking and drug taking. He was aged only 52 ...

Over the next few weeks I was invited by various magazines and outlets to reminisce on our time spent together and our professional association and off-track friendship. It was a real pleasure to dig up a heap of treasured memories ...

Barry, full name Steven Frank Sheene, who raced from 1968 until 1984 was world champion twice in 1976 and 1977, and they were the seasons that stand out in my memory. I was not at his first victory aboard a 125cc at the Belgian Grand Prix – but I was there for his final appearance riding a 500cc in Sweden. And I reckon I must have been a trackside spectator, writing for the *Daily Mirror*, at most of his triumphs. Aboard Yamahas and Suzukis with team support he had 23 wins from 102 starts with 52 podium, 18 pole placings and 20 fastest laps ... as well as a scary host of pile-ups that made him a frequent visitor to operating theatres around the world. He quickly became a household name for his wild exploits off-duty, and his heroic adventures and daring when he boarded his two-wheel challengers.

I was there when he luckily survived a 175mph horror crash

at the ultrafast Daytona circuit in the USA. I visited him in hospital as he winced from injuries that left him with six broken ribs and fractures to his wrist and collar bone. Apparently, his nurse told me, that when he came round after extensive surgery he called her over to his bedside and whispered: "Can you get me a fag? But don't tell the doctor."

We spent some wild times at his 700-year-old manor house in Charlwood, Surrey, bought in 1977 and once owned by actress Gladys Cooper when, no doubt, it would have been a much quieter and reserved location! He already owned houses in Wisbech, Cambridgeshire, and Putney in south-west London, his beloved birthplace, but he revelled in his newest poshest dwelling. "I feel like The Lord of the Manor" he laughed. His big pals, and frequent guests, were F1 playboy heartthrob and fellow wild-man James Hunt, the renowned swaggering high-life hero, with Beatles mega-stars Ringo Starr and George Harrison, and a host of other top-flight celebs all delighted to be part of and contributors socially to Barry's hectic series of get-togethers in between his demanding racing commitments.

All that spree-ing and relentless bedding of a long trail of glamorous girls came to a close unexpectedly when, in 1975, still on crutches from yet another crash, he met stunning, tall and elegant model and glamour girl Stephanie McClean, winner of a long list of national beauty titles and style awards, at a photo shoot for Chrysler. They hit if off straight away and she, later, divorced her husband to take up with Barry. "I am the luckiest guy alive," he told me, "and we are going to get married." He boasted: "I always tried to bed as many women as I could ... not any more."

He and Stephanie ran away together to a secret rendezvous and nobody, except me, could guess where their hideaway was. Backed by the sports desk at the *Mirror* I ventured to a hotel I knew was one of Barry's favourites ... the Zistel Alm, on Mount Gaisberg, in Austria. And I was right! They were absolutely

staggered when I pitched up at the hotel as they lunched overlooking the fabulous far distanced mountain views. But Barry welcomed me with a firm handshake and a hug and they happily posed with me for a world exclusive photo which was published in the *Mirror*, and then syndicated, and now has pride of place in the well-viewed gallery of my party-room wall.

Among my other memories of Barry at his most mischievous was when he was battling for the 500cc title against hot shot American rival 'King' Kenny Roberts, the reigning 500cc champion and one of the all-time greats, in their Silverstone showdown. Barry squeezed past Kenny at 180mph and as he overtook the flying Yank he put his hand behind his back and gave Roberts a two-fingered V-sign. It was an impudent gesture that cemented his fast-growing reputation among his many thousands of fans as the cheekiest of chappies with a unique sense of fun under the tensest of circumstances.

In another spectacular death-defying 165mph crash he hit fallen rider Patrick Igoa in practice for the 1982 British Grand Prix and fell off. He, with metal plates and 27 screws, and his victim were put in neighbouring beds in hospital and developed a friendship that was ongoing until he final departure. One of the first on the crash scene was Kenny Roberts, who later described what he saw as "Like a plane crash, scary!"

But let me go back to our earliest get-togethers and development of our mutual regard and friendship. In an elongated chat, not too long after he had broken into the world championship chase with a fast-rising reputation, he let me take him home for a fulsome afternoon of revelation and information.

And it went like this from his own lips:

"When I started racing, I was almost immediately dubbed the new Mike Hailwood, an opinion which pleased me – but one that put me under no pressure whatsoever. I know that lots of people

thought that the tag put on me would cause me to feel stressed and under pressure. But they were all wrong.

"I still rode and raced as best as I could without for one moment believing I was capable of doing all the things Mike could do on two wheels. I was only young and I realised I had plenty of time to develop my own style at my own pace. Sure, there was a need for another rider to replace Mike in the affections of the millions of enthusiasts all over the world who all wanted a new hero. If it was to be me then okay. I did not mind. Mike had retired and remained as a glorious memory, a hero, a genius, but somebody else had to emerge onto the bike race world championship scene. If that was to be me, I was happy to put in all the effort I could and take as many risks as was crucial to be a winner, a champion.

"The successes I enjoyed right at the start of my career were enough to make me feel happy and reasonably satisfied, if not totally content, but when I missed the chance of a world championship in 1971, my first year on the very hard fought international scene, I was bitterly disappointed. Mike had clinched his first world title at the age of 22. I was one year younger and it would have given me the greatest joy to have beaten him to a crown as a junior to him.

"The 125 world championship eluded me and went instead to Angel Nieto, a wee Spaniard but a giant of a racer. We had some tremendous confrontations throughout 1971. And it was certainly not for the want of trying I failed in my ambitions. I put everything I had into my all-out efforts to win the championship. And it is history now just how close I came to clinching the crown at my first attempt. But I felt I was on the way, with a warning issued to all my rivals, more established and experienced guys in the top-flight of really tough racing.

"When I look back on my career my only regret was that I did not start it much earlier than I did. I did not really get under way until I was 18, and really should have been in the saddle competitively much sooner. As it was, I felt as if I had wasted my time when I could well have been piling up some valuable additional experience.

Ironically my first two attempts to begin a racing career ended with me falling off each time, so I decided it would be safer to become a mechanic and I joined the continental circuit as a spanner man with the Lewis Young team. I grew, I suppose, in the fabulous atmosphere of racing overseas and it all helped to stimulate the way I felt about competing rather than being behind the scenes as a helpmate for established riders.

"So I swallowed hard and decided to give it another go, risks and all. And thanks to my father, Frank, who arranged for me to compete in our National meetings on 125 and 250 Bultacos. Dad did the business and persuaded Bultaco's big boss Señor Bultó, a pal of his for years, to give me backing. I returned the favour by picking up first places like nobody's business. And by the end of my debut season I claimed second place in the 125 British championship chase. Later, I suppose, I was able to repay him for his unfailing support, encouragement and trust in my ability by winning the 125cc British championship riding a Bultaco – but I felt it was only a meagre return for the unstinting backing he had given me."

It was about then that Barry and I became friends and all that firmed up when he decided to compete on the grand prix stage. In between times he opted for a go at the Isle of Man TT, the most dangerous and testing race on the planet, 37 ¾ miles of a challenge beyond belief over the Irish Sea island's narrow and bumpy roads.

Here I revert to Barry. He confessed to me:

"I frightened the life out of myself at the TT. I fell off at Quarter Bridge when my bike slid from underneath me. After Bray Hill, a terrifying plunge just after the start, a real test of guts, I did not know what was happening to me or where I was going and I was barely in control. It was all like a crazy madcap slalom with about a hundred other frighteningly committed guys all hell-bent on overtaking whoever was in their way. And that included me as I virtually tip-toed my way around. I was ever so grateful that I had crashed where I did, on one of the track's slower challenges,

because if it had happened anywhere else on a quicker bit I could have done myself some real harm. Lucky bloody me! Anyway, I thought, sod it, that's the TT over and done with for me forever more. The end, even if whatever team I was riding for wanted me to do it again. I do not want to know about the place. No thanks! Call me a coward if you like, but I would prefer to stay in one piece.

"*I had missed most of essential practice on the island because I could not manage to get there until late on in the week of rehearsals. So by the time I got to the grid I had done only eight laps ... nothing ... and as any TT regular runner knows that is just not enough. I was a bit silly to even think about racing. Phil Read, a TT great, generously helped me in one session by waving me to get behind him so he could show me how to get through tricky places like The Verandah where old ace Parlotti was killed in 1972. Phil, a regular winner and front runner, went a wee bit slower than he normally would so I could keep up with him. As soon as he leaned in anywhere I did too at exactly the point he had shifted himself and his bike to cope. But it all scared the pants off me. I was going far too quickly for my capabilities even though Phil regulated his speed. I just about managed to get through the hazards he made a meal of – but I realised I was right on the brink and likely to cop it if I wandered off-line. How I got through I will never know.*

"*When the race came, so did the mist! I had to lift up my visor to see where I was going and tootled along at about 15 miles an hour. Ridiculous! But I was not prepared to stick my neck out any more than was absolutely necessary. Even so, it all ended when the clutch grabbed and jolted my bike's progress so much so that it threw the back wheel out of line at the relative slow-point Quarter Bridge and chucked me off. I was grateful I escaped without being hurt. And that was that so far as any TT ambitions were concerned.*"

In a mode of total honesty he confided:

"*When I got onto the grand prix scene I went wild. In 1971 I went through the whole season like a lunatic with a never-ending quest for fun and frolic. There were always great-looking willing girls*

around chasing the riders ... especially me ... and there were parties galore with gallons of booze. Life was all in the fast lane. Whatever was available ... women or drink ... I grabbed more than my fair share. In Finland, for instance, I was out until nearly dawn and staggered to the circuit for the start – but, against all the odds, and still suffering from a hangover, I still won the 125 race by a clear 15 seconds. I went through most of 1972 like that, but halfway through the season when things and results started to go wrong I changed my errant lifestyle. And I signed up with Yamaha – not on a full works contract, I still had to pay my own way and find my own mechanics and back-up team. The bike was an absolute rocket and I won everything I contested in England – with a single and rare exception when the bike broke down. I could see my capabilities were taking shape – but I needed to adjust my lifestyle. And I did. My decision to quit the playboy madness saw me improve beyond my dreams with, eventually, two world titles and fame on a global scale that reaped immense rewards financially."

Although Barry and Besty never managed to get together, even though they each held the other in high regard, they did have a sort of join-up. They each autographed the ceiling of the bar in my old farmhouse home ...

Chapter 6
Mike Hailwood

I first met Mike Hailwood at the TT in 1961, when Mike, aged just 21, rode all four solo classes and became the first rider to win three races in a week. This was to be the start-up of the warmest of friendships that lasted until the time he perished so cruelly in 1981, along with his nine-year-old daughter, in a road accident that was not his fault, after surviving a racing career interrupted with crashes and peppered with near misses. Our friendship, and my involvement in his remarkable TT comeback in 1978 and 1979, is well recorded elsewhere, most notably in my book *Mike the Bike – Again*. Over the years I was lucky enough to befriend both his father Stan, and Mike's wife, Pauline, from whom I have included some personal communications below.

STAN HAILWOOD
In the early days of our friendship, I received a letter from Mike's multi-millionaire father, Stan, sent from his temporary stay in the splendid Grand Hotel, Cannes, on the French Riviera, after leaving his residence in Nassau. And here it is ...

"My dear Ted, Many thanks for your very kind and amusing letter which I have not answered until now because I was waiting for your book to arrive, but sorry to say, up to the time of writing,

no luck. I wanted to write and thank you all at the same time for your relationship with Mike.

"You must be dreaming to imagine me living the playboy life considering my 75 years!! Crumpet!! Despite what you say I have forgotten what that is like ... well, nearly. I am so happy you and Mike had a party together before he left. I can imagine what that was like!! I always wondered why out of all the news hawks that we knew that he had such a strong regard for you ... he never seemed to bother with anyone else. You either understand him very much (which I think is the root of the matter) or it might have been your mutual drinking capacity!!!

"I have had more letters from him since he landed in NZ than I have had in the past five years. He seems very happy and he has bought a house and is looking for land to build another.

"Good thing you didn't fly to Nassau because I have sold up my house etc and cleared out. It was getting just a bit too dangerous what with all the muggings etc, etc, and I was scared stiff of being attacked. I went to Barbados instead and that is beautiful. I lived in a hotel from where I was interviewed for 'This is Your Life' on telly. I hope you saw it and admired my grey ... or is white? ... hair and worried look.

"I am off on a world cruise pretty soon, taking in Auckland NZ so I will be able to see Mike and Pauline and the kids, and stay with or near them for three days. I really am looking forward to it very much – but I hope your book arrives before I go because Mike raved about it and I am dying to read it. I still eat, sleep and dream motorcycle racing. It is a terrible disease that gets into one's blood. I see you must have it in yours as you are still galloping to circuits all over the world. An old pal and one of the old brigade told me that it is not like it used to be and that the present day riders think and act like they are a bunch of prima donnas.

"I must thank you for making me a present of your book (when I eventually get it) it is very, very sweet of you. Anyway, Ted, keep up your valued friendship with Mike, keep fit and smiling ... all the

very best and, again, many thanks. I will write to Mike and tell him I have had a cheerful letter from you."

The message, such a treat to know how much he appreciated my friendship with Mike, was signed "From Your Old Buddy, Stan Hailwood."

From just about then onwards Stan never stopped trying to persuade me to quit journalism and work full time in support of Mike. He promised to better my *Mirror* wages! But I was enjoying my newspaper career far too much, with adventures and excitement galore, to even consider for a split second packing up my job on the *Daily Mirror*. And right up until today I do not regret my decision, as much as I treasured my connection with Mike. That I could cope with both segments of my interest – Mike and the *Mirror* – was hard work and time consuming, but it was as rewarding as can be. Bliss! I reckoned I was one lucky guy.

I was even blessed with a crowning glory – a summit of recognition that filled me with pride. I was voted Journalist of the Year and awarded the very rare Segrave medal for my efforts in taking the retired world racing legend Hailwood back to the Isle of Man TT in 1978 and again in 1979, both winning scenarios, and record-breaking events with the island's hotels and boarding houses absolutely sold out and camping sites jam-packed for a buzzing two weeks of anticipation and celebration.

As well as that historic and most memorable occasion for me and thousands of bike fans right across the globe, I revelled in an absolute mass of daily concerns during that time, like coverage of world dramas, wars and news stories galore, and packed with a non-stop stream of time spent with international celebrities, film stars, and sporting heroes. Sadly, some of them are no longer with us ... but many of them are still great friends.

(Continued on page 65)

Gallery 1
Early career, George Best,
Barry Sheene, and meeting Delia

Winners of the school cricket shield 1949. Me, aged 15, far right, dark trousers – 12th man!

My mother, Elsie, with the tamed jackdaw she adopted.

Butlins Pwllheli 1951, aged 16. I am third from the left.

Ted, or Eddie as I was known then, aged about 18 (smoking!).

What am I doing?

Down to
business on the
phone in my
younger days as
a journalist.

Never mind the ball – let's get on with the game! Me, playing for the Manchester press team.

Manchester Media football team, 1980s. I am 5th from the left on the top row – the goalkeeper.

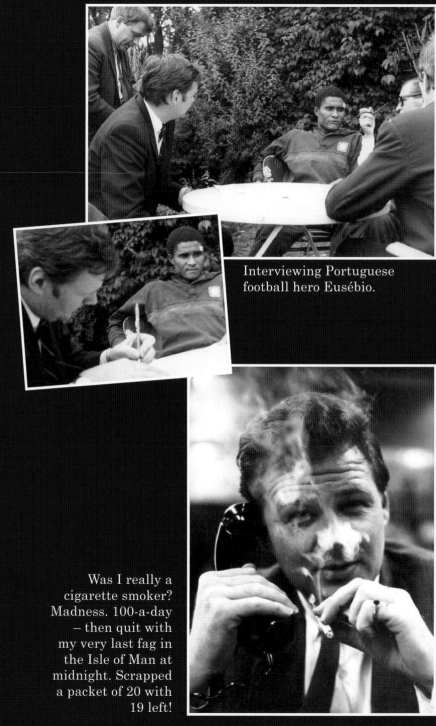

Interviewing Portuguese
football hero Eusébio.

Was I really a
cigarette smoker?
Madness. 100-a-day
– then quit with
my very last fag in
the Isle of Man at
midnight. Scrapped
a packet of 20 with
19 left!

Megastar singer Johnny Mathis – and Macauley. We share the same year of birth, 1935.

Ringo Starr and me meet up in the Isle of Man when the Beatles were on tour.

Don't ask me!

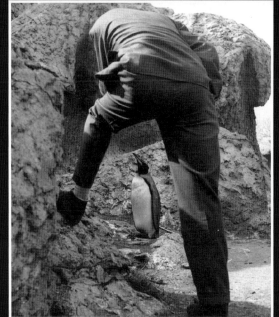

Talking with legendary singer and movie star, Andy Williams, who recorded 43 albums, 15 of which were 'gold' and three 'platinum'. He died in 2012 ... worth $45 million!

Seen here during my brief *Mirror* role as crime reporter. I am in the centre, wearing dark glasses, surrounded by newspapermen and TV reporters. I was covering 'The bodies on the moor' story, when Myra Hindley and her lover Ian Brady had murdered five children, and buried them on Saddleworth Moor between 1963 and 1965.

At work in a rented private jet.

Ted Macauley
at work!

Mike Hailwood,
bare chested,
and me at the
East German
Grand Prix at
the Sachsenring.

Doing my duty as a male model for the exclusive Manchester
superstore, Kendal Milne.
Below: Me modelling a yellow suit for Kendal Milne on a
photo-shoot at a Wigan coal mine.

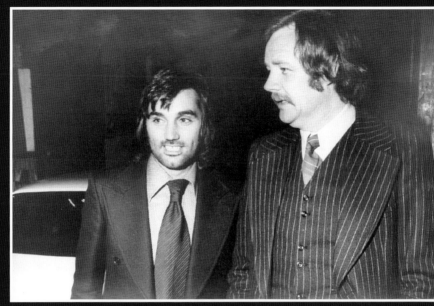

Me and my great friend George Best, the late world football
legend. He went missing in the UK and I found him in Marbella.
I flew there on a gamble having guessed he was in hiding in his
favourite foreign haunt, and brought him back to Manchester.

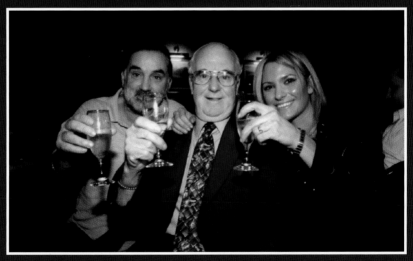

George with dad Dickie, and wife Alex.

Me with Besty, enjoying a drink before he went teetotal to my complete surprise and delight.

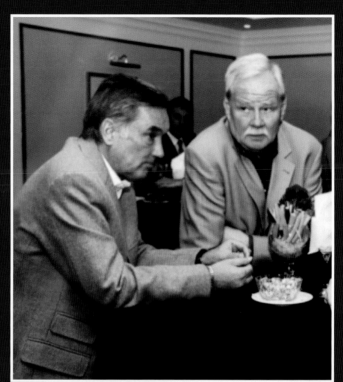

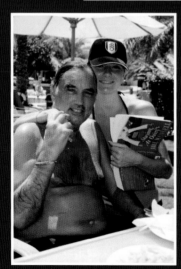

George and wife Alex on holiday with me and Delia, in Dubai the year before he died.

Barry Sheene and wife Stephanie at Austrian Alps hideaway where I found them at the hotel 'Zistel Alm' over Salzburg – a runaway wedding!

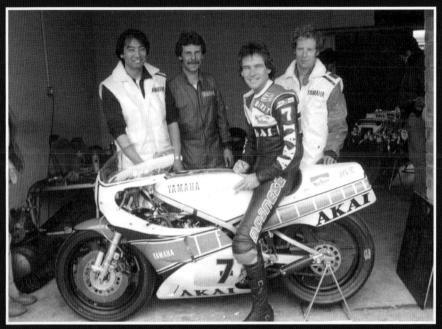

Barry in his Yamaha days – with back-up team.

Barry Sheene: twice world 500cc champion, 1976, 1977. Right: Barry
tries out a helicopter in Spain; he was also a pilot.

Don't forget to duck! A judo ace comes flying in – I was not a bit scared!

Delia Macauley, my wife, who I met in Tokyo, Japan, in 1987
and married on Lake Como, Italy 2003.

Delia with her prized possession Porsche in France 1997.

PAULINE HAILWOOD

Although many years ago now, the time and the memories lingered on for me. Sadly, more so for race legend Mike Hailwood's broken-hearted wife Pauline as, sitting tearfully at home, she recalled her devotion to her departed and beloved national hero of a husband who had perished in 1981.

She herself did not have much time left before she, too, tragically left this life suffering from cancer in 2020. It was my utter privilege to have a played a role in both their lives, as friend and manager of 'Mike the Bike' and confidante of his widow.

I recall the tearful get-together we had at her empty home with its photo, souvenir and prize packed shelves and walls. And I will never, ever forget it. I felt honoured to be so regarded by such a marvellous lady. As she cuddled their son David she opened her heart. A long interview published in 1981 went like this:

Through her revelations of her love of Mike and their life together, the abject sadness sometimes shows in her bright blue-eyes – and at times she is still stunned by despair.

Pauline, at 37, is a beautiful woman who is striving desperately to adjust to a life without her beloved husband Mike. He was the greatest racer of motorcycles the world is ever likely to see: a man who for 24 years staked his life on his towering skill, only to be killed with his nine-year-old daughter, in a road crash that was no fault of his own.

He put his bravery on show every time he rode and was awarded the coveted George Medal for it. Now it is Pauline's turn to be brave – but all she can win is an elusive peace of mind ... She sits in her comfy lounge behind the latticed windows of the home she shared with Mike in a village near Birmingham, and recalls:

"The other night I went to a film show that was all about Mike. It was the first time since he was killed that I have seen

him moving, laughing and talking. It was, honestly, a weird experience. It took all my strength not to cry out. But in one sense it keeps him alive in my mind. And that's what I like. Everywhere I go in this house ... our lovely home ... there is some reminder of him, some beautiful little memory – and they help keep me sane.

"I have changed nothing. I have kept the house exactly as it was the night he and Michelle went out and never came back. I just cannot understand people who throw everything away ... the clothes ... pictures, and souvenirs, and try to wipe out the precious memory of somebody they loved dearly. For me it is just as if he has gone racing and will be away for a while – then come home and back into my arms. I keep telling myself that – and not to expect him to walk through the door any minute because he's been racing. That way, it will gradually become normal for me to realise he is never coming home. That he has gone forever."

She cuddles her seven-year-old son David who, thankfully, survived the horrible crash and recalls:

"It all happened last March, but even now David still has nightmares about it. He never talks about it when he is awake – but I hear him jabbering away when he is asleep. So, obviously, his mind is still a turmoil. He staggered me a few days ago when he suddenly asked me why I don't get married. And when, quite shocked, I asked him why, he said he wanted another daddy ... I had to explain as best I could that I still loved his daddy very much and could not possibly ever love anybody else and, so, he would have to make do with me on my own. But I could see he was being very brave because he missed Mike and Michelle terribly.

"Mike was such a lovely man, a joy to be with and be loved by him. I used to secretly look at him and think that cannot be the same guy who has done all those incredibly courageous things. He was like two men. One at home, caring and affectionate, a family man through and through, content to be with me and our kids. Playing the piano or guitar and just getting on with enjoying life, despite the enormous pressures that never, ever eased. In his

other guise he was devil-may-care, the dashing, daredevil idol that everybody loves to love. It is the hero that everybody in the outside world knows – but to me he was just my darling husband, a doting daddy. Modest as can be."

Pauline, whose lovely face and shapely figure won her glamour roles in British movies, and earned her big money as an international model, tries hard to deaden her grievous sense of loss. She pauses, then confides:

"I have never told anybody this – but a few years ago I went in secret to see a palmist. Mike would have scoffed dismissively at my decision, but I sneaked along anyway. She told me that in 1974 I would have a great moment of absolute joy and satisfaction – but one of sadness, too. Well ... David was born in May. Then, in August, Mike had an horrendous and spectacular crash in a racing car in the West German Grand Prix. He nearly lost a leg and he was left limping heavily for the rest of his life ... he was fortunate to escape without being killed. Then, I remember, the palmist told me that the man I loved would be taken out of my life in my thirty-sixth or thirty-seventh year. When Mike came out of retirement and made his amazing victorious comeback at the very, very dangerous Isle of Man TT in 1978 and with a follow-up the year later I lived with this awful dread and the ever-so-sad forecast that I would be widowed. I did not dare tell him because I figured he had enough to think about the occupy his concentration – but ... scarily ... I lived on pins whenever he was racing. Imagine!

"When he eventually decided to quit I still held onto my little secret; the danger, thankfully, had passed. He had survived all those danger-filled years, living right on the edge at 200mph on two wheels every other week. And the palmist had been fooled ... And, just when I thought we could settle down to a life of sheer pleasure and relaxation without risk, he goes and gets killed in the direst of circumstances over which he had no control: a road crash that was no fault of his. I would bet he fought like a bloody

determined demon until the very last second of his existence. it just had to be something way beyond his control to take his life. Nothing else could have.

"That dear lady palmist did have one more forecast: she said I would remarry in my early forties. How wrong she was! Who could possibly have replaced a man, a hero, a father, husband and daddy like Mike? Nobody ..."

James Toseland

Motorcycle racing, over decades of coverage for international newspapers and magazines as well an abundance of book writing, was almost a love-hate relationship. It gave me more joy than I could wish for, with friends for a lifetime – but it also left me saddened and heartbroken as can be, with a compelling total of heroic riders, many of them good friends, who were killed putting in memorably brave and skilful efforts, in sheer daring, right on the edge on the sport's dodgiest and most challenging tracks.

A survivor, but only after several fearful and frightening high speed spills, is James Toseland, who, along with the legendary Mike Hailwood, mentioned elsewhere, has given me a lifetime of mixed emotions, on track and off, topped by a fine friendship and eternal regard for one another in every sense. Now, I recall with fondness some of the rewarding moments, and his feelings that I was selflessly treated to over my association with him before he ... thank God ... called an end to his world-beating career. And it goes like this. Here is an example of my published appreciation given a great show in a national newspaper far from renowned for its coverage of two-wheeled racing. And I quote:

The eyes that have guided him safely through the perils that inevitably overshadow his occupation stare without a blink or

waver, and he fires back on my question with rhetorical equanimity: "You think I'm mad, don't you? My mother certainly does. And she keeps reminding me!"

Toseland, three years into his career, and a multitude of bruises, fractures, scratches and scrapes, was at only 23 the youngest-ever world Superbike champion.

In season 2006, after an unsuccessful and frequently mentally and painfully in-between year defending the championship, he hit the high spots again with a runner-up position in the hard-fought WSB title chase and this year clinched the title once again in a season-long show of courage, skill and bravery.

And that, coupled with a flood of offers to switch to MotoGP to take on the brilliant likes of the fast rising Italian wonderkid Valentino Rossi, a genius and multi-champ in the making, left the talented boy from a humble Sheffield background facing a dilemma unique to any professional sportsman, never mind one who risks his life going to work at 200mph in a madcap flurry of equally fiercely committed and gifted hardmen who refuse to yield an inch of room or advantage on tracks staging melees of sheer heroism.

Toseland, as handsome as they come, and a talented musician and singer, was signed by Sony, and backed by rock legends Status Quo and jazz superstar Jools Holland, to quit motorbike racing and its intrinsic threats and chase a career as a pop star, for which they all, and others too, reckoned he was well-suited and equipped to do.

He spent many hours, long into the night and early hours, in a London recording studio laying down tracks for an album, a mix of his own compositions and his favourite rock tunes, and everybody agreed his front-of-band charisma and looks that appealed to the lasses when he plays the keyboards and sings with his own group 'Crash!' was a sure-fire route to pop's front row.

But he sensationally decided to shelve his musical options and their vast promise of wealth, celebrity and safety, to stay in the fast lane for what he regarded as the ultimate and most rewarding

thrill of them all ... motorbike racing glory aboard an 800cc Tech 3 team Yamaha in a two-year deal.

He told me then, "Okay, I know you, and just everybody else is convinced I am crazy. But I can't help myself. My mum, who always wanted me to go to the London College of Music because I was such an advanced piano player, believes I must be out of my mind not to take the chance I have been offered to change to a career in pop. The lads at Status Quo felt the same. But I was hooked on the bike race world and the intensity of its challenge. It was my drug!"

Every day after school in Yorkshire he practised on his grandmother's upright piano and filled her parlour with his singing and playing. When he earned his first World Superbike win, his joyful, mega-wealthy sponsor treated him to an £83,000 nine-foot grand piano, a precious Steinway, which dominated his later apartment in the Isle of Man, the scene of the spectacular annual TT motorbike races and the September Manx Grand Prix, all staged on the enormously challenging 37¾ mile road circuit, up, around and over the scary Snaefell Mountain.

"Music has always been my second passion," he stresses, "And motorbike racing my absolute obsession, the top of everything, the greatest buzz you can ever get. And especially when you are performing your own stuff – and it earns an audience appreciation.

"Jools Holland, himself a bike race fan, persuaded me to go on stage and join him to perform at one of his concerts in front of 25,000 screaming and yelling fans. It was a truly fantastic experience. The Status Quo lads all reckoned I was an okay singer and musician and could make a good living doing it all. And they very kindly offered to play a backing track for me on my album.

"My mum, still living up in Sheffield – was chuffed because she thought I had quit dangerous and risky bike racing for the pop scene. When I told her I was backing off the Sony plan for my future she told me in her usual honest and down to earth manner that she thought I was nuts. It was the same with most of my

mates, too. They all reckoned I was some sort of crackpot to want to keep sticking my neck out and risking my well-being, as every racer does, when I could have a nice comfy and glamorous life on the music scene."

I reported at the time that if his new worldwide schedule on two wheels allowed it he planned to do 15 gigs a year – generously and for charity – with his own four man band. He was boosted by the fan following and rarely pulled in fewer than 10,000, mostly weeping, wailing, screaming girls, wherever they performed up and down the country. The adoration would have tempted the impressionable – but not the fiercely committed racer Toseland.

But he confided: "I have decided not to let anything ... and I mean anything ... get in the way or divert my concentration from winning the world superbike championship again. That is my absolute priority. My goal. My dream. My hope. My everything. Even if from time to time it does give me some hurt and disappointment."

And hurt it most certainly did, especially when he was pitched off his machine in a terrifying crash when the brakes failed at 185mph! And he lost count of the breaks, bruises, strains and pain-filled days and nights spent in hospitals or trackside medical centres. "The pain goes with the territory," was his philosophy. "If I worried about crashing I would be out of order. And I'm happy to make all the sacrifices necessary to be the world champion."

He revealed surprisingly: "I don't have a regular girlfriend. I tell them dead honestly that I am not interested in a long-term deal or marriage, however lovely they are, and they can take it or leave it. If I can contentedly and happily give up the idea of being a pop star with a great career in music, and all the fun and frolic that goes with it, then it must be proof of my determination and devotion to race. From being a youngster

all I wanted to do was being a success as a singer and front man in the music business ... then bikes came into my life, my hopes and dreams, and I was hooked for evermore."

Even that critical crossroad which came when he was just in his teens had its heartbreak setback. The man he regarded as the father he never had who had taught him to ride a motor bike and encouraged him to race, his mother's boyfriend after her marriage collapsed, tragically committed suicide.

"What with the awful situation and my team-mate being killed the day I broke both legs in a smash in my first race in Europe, I had to cope with some extremely serious setbacks and dilemmas. Quitting recording music and songs, against all the encouragement from Jools and all the Status Quo boys, my mam and just about everybody who knew me, was just another problem I had to cope with. I figured that when I would be standing on the podium as champion, I told myself I would have made the right move in packing up my music ambitions."

James's recall plummets him right back to the darkest and most hurtful day of his life when the generosity and unstinting devotion to him of his loving mother's fiancé Ken Wright came to a crushingly cruel finale. It was at one and the same time a turning point when, as he recalls close to tears, you have to come to terms with the awfully wicked setbacks of life and condition yourself as best you can, however unconsciously, to cope with unexpected and unanticipated harsh reality.

He explains: "I was a skinny kid with a tooth brace and spectacles and the other lads at my school called me jokingly and disparagingly 'The Pianist', not in a remotely complimentary way at all. Then, almost overnight, the hurtful jibes all stopped when I became, instead, something of a hero in their eyes ... a biker ... a racer going for it. And that, mercifully, was all down to Ken Wright.

"I was in bed one night in our little council house when I was

awakened by somebody playing our piano. I knew my brother Simon didn't have a note in his head, neither did my mam. And my grandma wasn't there. When I sneaked downstairs there was this guy I had never seen before ... Ken ... playing Ray Charles and Jerry Lee Lewis stuff. It was amazing. A real eye opener. And, even better, I could see he had parked a Yamaha YZF1000 motorbike in front of the house.

"He was doubly a bike fanatic and mad keen on music, especially playing the piano. What more could I desire in a super fella who loved my mam to bits and just wanted to be dad to me and Simon. As time went by he taught me tons of music, got me excited about pop, and at the same time fired me up about motorbike racing. His thoughtfulness was truly amazing. He was worried that Simon, who was more interested in football, might feel left out when he bought me a 125cc bike to race. So, as compensation, he bought my brother a motor car.

"In happy and eager return I gave Ken everything he demanded of me and was only too ready and anxious to please him, even if racing was not my mother's idea of a career for her son. She was convinced I would be better served pursuing a career as a musician.

"At the age of ten, encouraged and funded by my stand-in dad and promoter, I competed just about every weekend and won trial championships galore having the time of my life. I never gave a second thought to the risks I faced. I was flying on Cloud Nine. I was enveloped and engrossed in delightful times and there was no way I could have predicted from those joyful moments that a heartbreak was looming.

"I progressed to road racing, and at 13 was doing really well ... so much so I won the Junior Road Race title. I could not have been happier, more satisfied or content with my existence. But desperate sadness was looming unseen as a complete unanticipated shock ...

"I arrived home from school one afternoon I will never forget and was horrified to see smoke pouring from under our garage door. Our post lady had already called the police – and when

they broke in they discovered Ken dead in Simon's car!! He had committed suicide. Gassed himself on the exhaust fumes. I was totally devastated. I couldn't believe it. It was only much later we learned that he was a schizophrenic!

"I was inconsolable. And broken hearted that God had taken away my beloved and admired Ken. In a desperate effort to get over the intense shock I just rode and rode and rode my aged motocrosser around the colliery slag heap, trying to distance myself from my anguish. I can remember riding to the top, sitting astride my bike and raising my arms to the skies and screaming to the heavens in utter despair. I felt cheated that I had been robbed of the care and concern of a fine man who had been such a life forming influence. His legacy remains with me – his ability and strength to cope however tough and challenging the setback.

"It is a dedication that I will carry with me when any new phase of my career occurs." he said. And that came when racing kicked off in the MGP's season opener in Losail, Doha, in March, where he scored a first and a second in two clashes.

The Toseland trek to the top of the world was jammed with incident, fun and outright success that earned him millions of pounds and benefited him with a lifestyle he could hardly have ever imagined as he sped from anonymity to global fame ... and there was a bout of mischief looming.

It happened this way. James's personal sponsor and long-time admirer, John Jones, the boss of the country's biggest plant hire company, was at Magny Cours, France, for James's debut WSB victory on a Ducati.

At the start of the season they had been watching TV together when John asked James what sort of piano was it that mega-star musician and singer Elton John played . "A six-foot grand," answered JT. And Jones promised: "When you win your first race for me I will buy you one of those."

Later, watching James speeding to his maiden WSB win,

John announced loudly: "I feel a piano coming on." And he was as good as his word. He took James to a music shop in London with JT expecting his sponsor and pal John to spend no more than £45,000. Wrong ...

The sales lady gave James a tour of the superbly stacked showcase shop and he tried out several instruments before settling contentedly on a nine-foot Steinway grand. "How much is that," he enquired. "£83,000," came the cool reply. And James swallowed hard ...

"But John didn't even blink or blanch for a split second," recalls James, "Even if it was nearly double the price I had suggested. And he treated me to it. Readily. And eagerly. Chuffed that I was chuffed."

But let's move on ... nearer the time when James quit the scene he loved, the spectacle that had left him very well off, a champion respected all over the world, admired and, impressively, as modest when he packed it in as he was when he kick-started his debut charge for success.

Chapter 8

The Isle of Man

There can be no mere geographical specks of land as world famous as the Isle of Man, a miniscule blob of earth, 30-miles-by-16, 221 square miles, midway between England's Liverpool port, 89 miles distant, and Northern Ireland's mainstream Belfast, 61 miles away, and rising mountainously from the colourful and lively backdrop of the Irish Sea.

Also known historically from its Celtic and Viking heritage as Ellen Vannin and Mann, the self-governing crown dependency Isle of Man, a tax haven with its capital Douglas, and 85,000 population, stages the most spectacular, exciting, dangerous, revered and treasured motorcycle race on the planet ... the Tourist Trophy ... the quintessential TT, an unforgettable ear-splitting and colourful experience for both heroic and committed competitors and thrill-hungry spectators alike. The 37¾ mile course, taking in a tricky and testing ascent on the winding and dodgy road over the snaky Snaefell mountain, 2036ft high, and flat-out 200mph racing along bumpy, often rain-drenched or foggy, stretches of tarmac with barely enough room to overtake in treacherous elbow-and-knee clashing duels is the sternest test of all for its courageous two-wheeled combatants. It was first staged in May, 1907, and has been growing with ever-increasing popularity ever since. Wow! Some 250 competitors – one of them a married woman, Swiss Marie Lambert, a daredevil

sidecar race passenger – have been tragically killed in crashes and bizarre unpredictable events since the early days. Six of them in one utterly disastrous and heart-breaking week. Add to that, Lord knows how many eager-beaver and reckless fans have perished over the years, foolishly and rashly, devoid of the necessary and crucial skill, vainly emulating their heroes across the scarily threatening stretches of the public road 'racetrack' without suitable machinery or abiding by the essentially cautious and widely publicised safety advice. Over a dinner with regular daredevil but superbly controlled winners like Yorkshireman Mick Grant, first seven times with 16 podiums, and Cheshire-born Charlie Williams, with nine victories and who later became a knowledgeable broadcaster and TT pundit, we counted up and named the numbers of riders who over decades had become personal acquaintances, some special friends ... not that we just knew of, but that we recognised as pals, and it amounted to around 40 when we stopped counting the death toll. And, quite honestly, you would not know that many victims of a world war.

My debut professional outing to the island was the 1961 TT – when I first met fast developing race ace Mike Hailwood and his wealthy father Stan for the start of friendship that was to survive uninterruptedly strongly until Mike's tragic car accident in 1981. I had originally been taken to the island by ferry from Fleetwood by my mother in 1945 for a 'holiday abroad' as the adverts called it. I have returned at least once a year ever since, business and pleasure. Mind you, covering the TT and the September Manx Grand Prix was, and still is, a combination of both. The island is almost as attractively old-fashioned now, with very little change or overall appearance, as it was in my early days of B&Bs, bed-sits, terraced front promenade stopovers with views of the harbour and the historic Refuge Island, a couple of hundred yards offshore, a rescue point for sailors in trouble. There are families going

back centuries, a mountain railway, horse trams, Manx Ales, and tasty smoked kippers, which started out in life as locally caught herrings, plus an overall feeling of goodwill among the welcoming locals. Its oddball logo is a three-legged symbol tagged in Manx: "Quocunque Jeceris Stabit" ... translated into "Whichever Way You Throw Me, I stand."

On one of my early flights from Liverpool to Ronaldsway, the busy island airport, the pilot of our DC3 – an ex-RAF aeroplane I suspected – announced we were ten minutes away from touchdown and broadcast jokily: "We are about to land in the Isle of Man ... turn your watches and clocks back 300 years!"

He also warned us that to cross the haunted Fairy Bridge on the road into town from the airport without the warm and loud greeting: "Hello Fairies" could result in an accident set up by the invisible troublemakers. And we were alerted to be careful not to run down one of the IOM's scores of fabled tailless cats.

Over the decades, while journeying to the island by comfy, convenient and relaxing ferry to Douglas, from Liverpool or Fleetwood, with one of my own cars rather than a rented motor, I amassed memories galore of people and events. I had no idea that early on I was making an impression, despite my name being featured on hundreds of colourful *Daily Mirror* posters carrying my mugshot, and bearing the slogan "Stay Out in Front with Ted Macauley" ... with the flattering and embarrassing tagline "Britain's Best Informed Motor Cycling Journalist." They were showing on just about every lamppost and bare wall promoting my TT coverage to a level I never imagined. I lost count of the times I was asked to autograph one of the bills snaffled from its setting, only for it to be replaced overnight by our publicity department's Manchester-based rep, transferred to the island for the duration of the races, a week of practice and another of actual racing.

One afternoon, I think I was aboard the Lady of Mann sailing to Douglas, I could not believe it was my name I heard being tannoyed as I swigged a vodka-and-tonic in the jam-packed forward bar. "Would Ted Macauley urgently come to the bridge," was the message. A joke? I had to find out – so up I went. And there, waiting to greet me with a handshake was the ship's captain. In his hands he held a folded black uniform crew-neck sweater and an IOM Steam Packet Company sailors' cap. "I am pleased to announce: You are now Honorary Able Seaman Macauley," he said as he shook my hand and handed me the weighty weather-proof staff-issue woolly jersey with its message of identity across its chest, plus a sailor's round flat cap. "With a million thanks for all your efforts and publicity in the *Daily Mirror* to keep the Isle of Man in the public eye all over the world." The souvenir Steam Packet clobber still has pride of place in a show cabinet stuffed with TT mementos and programmes in my home office. On the same TT trip I stayed at the upmarket, central promenade seafront Palace-Casino hotel, managed by an old friend, Alex O'Brien. He had been persuaded to switch from his ever-so-popular privately owned pub, my regular call-in near the airport, to take over the residential-side of running the newly opened Palace Casino under the overall steerage of Sir Dudley Cunliffe Owen, a blessing of a very posh and talented boss and another, eventual, firm friend.

When, job done, I set about leaving the island, attired fondly and for fun in my Steam Packet gear, I squeezed into my sky-blue E-type Jaguar which had been parked, hood down, behind my Palace-Casino stopover, and was surprised to discover on my passenger seat a huge shiny and spectacular one-armed bandit, cloaked under a lightly draped hotel bath towel with, on Casino headed paper, a simple handwritten: "Thank you. You will always be a winner!" It was a gift from Alex O'Brien, still loaded with gambled sixpences, removed

surreptitiously from the vast gaming room in the early hours by one of his cohorts without Sir Dudley's knowledge or, I guess, his permission.

In between the fulsome times spent listening to the deafening roar of flat-out motorbikes, and struggling through the masses of thousands of mad-keen spectators, mostly all mounted on pricey machinery or antique models, I had to visit Manxland to cover stories and happenings far different from the June and September high-speed clashes. Among them, the launch in 1966 of the first ever British licensed casino in the Castle Mona, then the IOM's premier hotel, first opened in 1836 and now closed. The launch was performed by the rising movie star who was to become, to my mind, the best James Bond ... Scotsman Sean Connery, by then far from the super suave hero he eventually developed into. And, watched by a host of dinner-suited gamblers, he dropped a clanger, as it were, at the opening ceremony by letting the ball flop from his chest-high fingers into the roulette wheel instead of smoothly rolling it in the opposite direction of the slowly spinning wheel. The result was inevitable: it bounced up and down a several times ... plink-plonk-plink ... and then rolled onto the floor and historically rendered the first-ever gamble in the casino a non-goer.

The star-studded Round Bar in the Palace-Casino was THE social hotspot, never not buzzing with free-spending boozers and VIPs present until the 4am first light ... and the start of dawn practice for the racers. I was a regular shameless attender, often the embarrassed focus of attention by party-going TT fans sending treats of vodkas-and-tonics to my hideaway corner in the bar that became a major and memorable feature in my own personal history. How so? It was the midnight scene of my very last smoking of a cigarette. Nutcase me, I regularly puffed my way through around 100-a-day. Yes, one hundred! And the lung and breath-wrecking, clothes-smeller Capstan

Full Strength, was my costly habit. I bought my final pack of 20 on the stroke of midnight, took one out, clamped it alight in my pursed lips, deeply drew in its foggy, smoggy, tongue-torturing fumes and then squashed it in an ash tray overloaded with fag ends positioned on the bar top. Then I ripped open the pack, took out the remaining 19 health-wrecking tubes and dropped them ceremoniously one-by-one into a bin given to me by the barman. The resultant cheers from those nearby were a treat – and a couple of onlooking customers copied me and abandoned their cigarettes. After that the only thing I ever smoked was one chubby cigar, accompanied by a vintage brandy, on New Year's Day

In stark contrast to my money-saving and lung-preserving sacrifice, was chain-smoker, my good friend and rival, Leslie Nichol, then the *Daily Express* motorsport reporter, as splendid and superbly mannered as a chap as could be. He was on the telephone in the packed media marquee in the paddock behind the TT grandstand, dictating copy to his London office with, as usual, a lighted, cork-tipped cig dangling from his lips when Prince Philip, the Duke of Edinburgh, a special guest at the event, accompanied by an Auto-Cycle Union official, popped his head briefly into the tented area loudly remarking: "Oh, this is where the scum work is it?" Nichol, a fervent royalist, phone still in one hand, notebook and ballpoint pen in the other, dropped everything in amazement at the unexpected regal presence, and grabbed the half-burnt but still alight fag from his mouth and hastily shoved it into the top pocket of his blazer where he had stuffed a paper hanky. The smoky result was inevitable ... so was the laughter among the gathered throng of newspapermen.

Chapter 9
Close encounters with the stars

Here's a claim – (name-dropper? Me?) I share with Hollywood movie legends Cary Grant, Rock Hudson, Edward G Robinson, Arnold Schwarzenegger, Walter Matthau and great Brit funny man Kenneth More, a real life close-up, inches away, of the revealingly-clad busty movie sex symbol Jayne Mansfield. I survived a right hook from her angry husband Mickey Hargitay, the 1955 Mr Universe, in a one-sided punch-up in a top-class Blackpool seafront resort hotel. It happened when Jayne, a sex symbol with a 40-21-36 shape, and a rival to glamour-puss Marilyn Monroe, switched on the spectacular promenade illuminations in 1959, following in the tradition of international stars, sporting heroes and famous personalities like Anna Neagle, Wilfred Pickles, Stanley Matthews, Valerie Hobson, George Formby and Gilbert Harding – and ahead of Gracie Fields, Ken Dodd, Shirley Bassey, Frank Bruno, Les Dawson, Status Quo and Sir Matt Busby.

JAYNE MANSFIELD
The petite but ever so shapely *Playmate* magazine cover girl, five-feet-five inches tall, eventual mother of five children, married muscle-bound body-builder Hungarian Miklós (Mickey) Hargitay and starred, mostly lightly clad, in a host of hit movies. She was the first actress to perform a nude scene in *Promises! Promises!* in 1963. She only did that after,

she revealed, she had swigged loads of champagne to get herself relaxed and in the mood to showcase her shape ... she stripped three times ... once for 59 seconds, then four seconds and, finally six seconds. She had claimed a list of oddball beauty titles ... Miss Photoflash, Miss Magnesium Lamp and Miss Fire Prevention, but turned down Miss Roquefort Cheese because, she protested, it didn't sound right. Along the way she revelled in flings with Robert and John Kennedy, the US diplomat brothers.

In 1959, at her peak, the biggest name ever to be so honoured, she was invited to switch on the Blackpool holiday resort's spectacular illuminations. I had been just short of a year as a news reporter on the *Daily Express* in Manchester, the national newspaper of my dreams under the news editorship of one Tom Campbell, a gifted Scot and a fine driving force, and a joy to work for. He assigned me to the seaside switch-on attended by thousands of spectators. I was then anxious to make my name and establish a reputation in the fiercely competitive news gatherer's market. I must confess I didn't see that covering the Jayne Mansfield appearance would enhance my reputation much further on the intensely fought and challenging national newspaper battleground. I was wrong! Totally unexpectedly, the opportunity came right out of the blue. Jayne, all dolled up and looking like the superstar she was, was accompanied by Hargitay, who cuddled their infant son, Miklós, just about one year old. When she completed the ceremony and flicked on the flashing and dazzling illuminations that blindingly lit up the night sky and reflected on the Irish sea, stirring a deafening and immense roar of approval, whistles and cheers, Hargitay, arm outstretched, one-handedly hoisted his bewildered, disturbed and weepy son into the glare of flashlights and ribbons of bulbs amid an echoing and chaotic uproar. And held him there. I couldn't believe it.

When we all got back to the hotel I planted myself in a quiet corner, out of the hearing of the media throng, and telephoned the National Society for the Prevention of Cruelty to Children to complain that Hargitay's showcase exhibition of his baby son was well out of order. Within the hour, two NSPCC inspectors were on the scene and interviewing Jayne and her hubby about their showbiz antics that had upset their wee one, who should have been in his cot instead of being featured in a raucously noisy furore. I spoke to the inspectors, got their confirmation they had acted and had warned Jayne and Hargitay. No other newspaperman knew what had happened – and I was chuffed to be left with a massive banner headline scoop that was exclusively front-paged by the *Express*. It was my longed-for and long-awaited breakthrough on the national newspaper scene. A special story for our four million readers. A major exclusive.

The morning the story splashed, my office got a call from Jayne's PR aide inviting me to meet her and Hargitay at the Imperial promenade hotel where they were staying en suite. And that's when the fun and frolic, dubious as it was, started …

My knock at the door of the posh suite was answered by Jayne. And I was taken aback. She was dressed in a flimsy, part-see-through pink robe barely covering her figure with scanty underwear on display. She stepped back and beckoned me forward. That is when her short-tempered husband came into play. I'll wager I was not two strides into the suite, inevitably gawping at Jayne's incredible image, a privilege to be remembered for ever, when Hargitay roared something I guess in Hungarian and swung his right hook at me. Whether it was his contemptuous miss or my adept swiftness in ducking and dodging, but his fisticuffs faded into only a glancing blow that I barely felt thanks to my heavy overcoat shoulder pads. A Burberry benefit. As much as he wanted to so evidently, he

failed to follow up because a worried Jayne stepped between us with a tearful apology ... and ordered him to another room in the suite. Then she invited me to sit by her as she poured me a coffee with an apology for the attempted assault. I told her I was genuinely concerned about the showing-off of teeny-weeny Miklós, and the article had been a facility to air my feelings which were widely supported. But, also, that I had regrets that such a universally admired and liked lady – and her angry, bad tempered hubby – had been so upset. But she vowed nothing like it would ever happen again – and that we should stay in touch. Not that we did. She was so much in demand. Right until her tragic and early death in June, 1967, in a car crash in America. She was just 34. Husband Mickey, a part-time movie actor, lived until 2006, when he died in New Orleans aged 80.

LEE MARVIN

The second telling, and unexpected, punch, another significant close-up for me, followed some years later, when megastar Lee Marvin, the film baddie, a tough guy in real life as well as acting as one on a movie set, clouted an assistant on the Irish set of *The Big Red One*, his last big role, alongside newcomer and rising star Mark Hamill, and almost a carbon copy of his real life as a Purple Heart-decorated Marine hero from the Korea-versus-US conflict.

We were introduced at Ardmore Studios in Dublin, and a couple of days later got together again at 6am at a countryside location 20 miles from the Republic capital. When we shook hands Marvin swapped a can of Carlsberg Special, the extra-strong lager, from his right to his left hand for his greeting. Then he placed it out of sight, alongside half a dozen yet-to-be-swallowed bottles, behind his uniformed legs – but insisting I sampled a taster, too. Which, as a non beer drinker, still am, and certainly not so close to dawn, I reluctantly accepted and

did a pretend swig. Then he re-joined me with a gulp that emptied in one swallow his handful of the strongest of ales. I don't know how it came to light but we found that we shared a birthday, February 19 – the month, not the year! – and he insisted we partied at his very posh Royal Hibernian hotel back in Dublin that night after filming. After a brief shoot, finished in about an hour, we sat down, each with yet another bottle of booze, as he recalled his role as a tipsy tough guy in the 1965 mega-hit and off-beat 96 minute Western musical movie *Cat Ballou* alongside Jane Fonda. And he confided with a deafening guffaw that was heard by all the crew: "I didn't PLAY drunk, I WAS drunk."

As we chatted, an assistant, eager to help, knelt unspeakingly in front of Marvin and began to unlace his boots. At which point Marvin cuffed him and gruffly berated the bewildered helper: "NEVER ... and I mean NEVER ... touch a Marine's boots." Leaving the poor lad stranded and baffled – but then swiftly hurried clear by another assistant. At that stage, with Marvin still attired in his grubby uniform, we climbed into a chauffeur-driven limousine for the journey back to Dublin. The driver, I suspect, may also have sampled a lager because he was a wee bit erratic. A matter noticed by a police patrol car. When they stopped us they were aghast at recognising Marvin, still in his Marine attire, and volunteered their support driver to take over the wheel with his comrade as the escort, clearing and paving the way in the cop car.

And the liveliness didn't stop there. A wobbly Marvin, heading straight away for the downstairs bar, his regular stamping ground throughout his stay, scared the life out of me when he stumbled and bounced down the staircase, miraculously righting himself without any help from me as he rolled up to the bar ordering: "Two beers ..."

New Yorker Marvin, white-haired before his time, the star of memorable movies like *The Delta Force*, *The Dirty Dozen*,

The Man Who Shot Liberty Vallance, The Big Heat, Point Blank, The Killers and plenty more winners, won the Academy Award for best actor in a comedy Western, *Cat Ballou*, his favourite and fulsome dual role as a double-identity baddie and a gunfighter, died far too early at the age of 63. But he had lived life to the full. And don't I know it after spending a lively week in his mischievous company. If my memory serves me right!

In half a century of world travel and spending entertaining hours with an endless parade of household names I look on the souvenir photographs on the walls of my bar at home and am treated to memories galore … high-profile world renowned personalities, films stars, footballers and showbiz legends … and am left inwardly smiling at the delights I inherited from them all. Don't ask me why, but two of them readily spring to mind as sheer joy: two knights, in fact. Namely Sir Richard Starkey, MBE, otherwise known as Ringo Starr, the Beatles drummer, and Sir Michael Caine, the actor.

RINGO STARR

One of the most spectacular assignments I had with the *Daily Mirror* was being on a six-week tour with The Beatles when they first started out and earned instant admiration and adoration from the word go. *The Mirror*, with a circulation of five million readers, dedicated huge full page features to the Liverpool quartet, and I grew to know Ringo more than his bandmates. I don't know why, but we hit it off. He was the cornerstone of the group, a quiet man in private and an extravagant drummer on stage, even now after 60-odd years. "We just love your show pages in the paper – and thank you very much, they are well appreciated by all four us," he told me as we sat together over a glass or two in the bar of the Isle of Man's posh Palace-Casino hotel, set on the Douglas promenade. He didn't know it then,

but he was go on to global fame and reputation, not only for his drumming, but for recording of a long string of hit singles and best-selling albums that earned the band $350million. We met often, worldwide, and his attitude and friendship never faded, even now, at the time of writing when he is 88 years of age.

MICHAEL CAINE

In a completely different world, movie legend Michael Caine, later knighted, came into play so often we were on first-name terms. I first met him playing a war hero on the films *The Eagle Has Landed* in 1976, then a year later on *A Bridge Too Far*. When I strode onto the set he spotted me and shouted: "Oh, no, not YOU again." We paired up again in Dublin on *Educating Rita*, in which he starred with the unashamedly admiring funny girl Julie Walters in 1983 – and we spent a good few hours over a drink or two venturing down Memory Lane, in a restaurant packed with eavesdroppers who recognised him despite a big beard for his character. In his illustrious 60-year career he played in 130 movies which have grossed $7.8 billion – and he is now reckoned to be worth $75 million. But, marvellously, he always retained a down-to-earth attitude. And despite the inevitable plaudits and mad-cap fan base he has always insisted: "I'm so chuffed. I am very lucky, I am a working man in a fantastic job. I pinch myself to remind me where I came from, my background, and the hard work I have happily put in to my life. Let's hope it goes on ... I'm not quitting."

Chapter 10

Bernie Ecclestone

I was awakened mid-afternoon by the gentle tapping on my shoulder by a nurse as I slumbered in a post-operation daze after four-way heart bypass surgery in a private hospital in London. And she whispered: "If you want to take it there's a telephone call for you." She handed me the phone and a distant voice announced: "Its Bernie here ... Bernie Ecclestone." And he queried: "Are you OK? The nurse tells me all has gone to perfection. And that's a real money saver for me. I was putting cash aside for a wreath." Typical ...

The double-billionaire's light-hearted intrusion gave me my first laugh since the scare of the life-threatening setback had darkened my outlook. And it was typical of the man I had grown to know, trust and admire over 40-odd years of ups and downs for the both of us, with highly private and personal get-togethers to share concerns and glee in equal measure.

Bernie's mischievous sense of humour, usually deadpan, strikes you even before you get to meet him. As it did with me. Our first get-together was in his office for an interview for the *Daily Mirror*. I was guided to a private room. As I gawped around I noticed a mock-up stack of $10million on a shelf in the waiting area, a few short strides from his sumptuous office in one of London's most exclusive and expensive stretches of real estate.

And the pile-up of phoney cash was what intrigued visitors to

Number Six, Prince's Gate. I was studying it in curious close-up when the dapper little man, neatly Savile Row suited, entered the room and offered the gentlest of papal-type, two fingers only, handshakes, saying: "Ah, I see you have found where I keep my small change." It was a clever mood setting intro, a pointer to the deliberately unsmiling figure's underlying sense of humour that remains a major feature of his personality to this day.

Bernie is well aware that his gaunt and crinkly face, topped by unruly, thick and floppy silver hair, depicts a stern immovable and resolute image that, in truth, is vastly distanced from the reality and the inner warmth and cosiness of the man himself, a mystery to many outsiders. That is not to say he has not been for generations one of the world's most formidable, feared and respected negotiators and shapers of universal business on a mega scale.

From being flat broke after being born into a monetarily hard-pressed family, he single-handedly developed a cash and business flow from his schooldays, selling newspapers to his neighbours and comics to his school chums, all of which stands out prominently as business acumen and an unquenchable hunger for achievement whatever the personal and time-consuming sacrifice.

His status is universally recognised as a quids-in double billionaire, among the very richest men in the UK with, I guess, just as much money stowed away elsewhere in the world. And it is all down to his gift for massive business dealings and negotiations with heads of state, the toughest of cautious international tycoons and difficult, hard-to-please Grand Prix luminaries, many of whom have succumbed to his wheeler-dealer skills and haggling genius, a painstakingly nurtured skill that has triumphed in securing eye-watering fortunes from money men over decades of ceaseless effort and persuasion.

Chapter 11

What they said about me ...

When I contacted two of my former *Daily Mirror* bosses and a host of sport and celebrity figures, all firm friends, who had featured so vividly and frequently in my magazine and newspaper columns worldwide over decades, I did not anticipate the fervour nor the outright and embarrassing praiseworthy responses that came flooding back to give my ego a boost beyond belief. Big Head! But here goes ...

Bernie Ecclestone, the genius who single-handedly fashioned Formula One as a mega-major attraction and, as a result, to Britain's benefit, attracted countless millions of pounds of investment from just about every corner of the earth, has been a close and trusting confidante and treasured friend for all the time I have been connected with Formula One. He said he was only too delighted to recognise the benefits of our professional tie-up and continuing association. On his letter-headed notepaper, as succinct as ever, he wrote:

"I have had the pleasure of knowing Ted Macauley for more than 40 years. During our long acquaintance Ted has always been professional and trustworthy and any interviews I have given him have been honourably taken. In addition to being an experienced and exceptional journalist he has been a pleasure to work with throughout the many years I have known him and enjoyed his company."

Another long-term friend from the Grand Prix scene, both four wheels and two, is fabled and respected broadcaster the late Murray Walker who, along with his delightful wife Elizabeth, has figured extremely prominently in my and my wife Delia's social life, both at our home in Surrey and theirs in Hampshire, an hour's drive away, as well as in exotic F1 settings in foreign parts. The airwaves legend, deservedly honoured with the OBE, says:

"As motorsport commentator for BBC TV, ITV and various other worldwide television and radio channels since 1949 it has been my pleasure and privilege to have known Ted Macauley, covering the same scenes as me, as a colleague and personal friend for a long time ... in excess of 50 years.

"Ted is a big man with a big personality. He has an outgoing and friendly manner, a well-developed sense of humour, gets on well with people, however famous they are, and has a great ability to turn his knowledge and experiences into interesting and authoritative prose. He is definitely a professional who I would want on my team."

Bryan Robson, the Manchester United and England superstar captain, another lifelong confidante, even now after his playing days, recalls and writes:

"I got to know Ted very well at the build-ups for the England international matches. Ron Greenwood, the manager at the time, would let the players meet in the bar for a pint or two after the games. And the journos would be there as well, mixing it with the players and staff.

"I would usually end up talking to Ted – and he very quickly became somebody I could trust and whose company I enjoyed. Many of the journalists at the time would let you think the conversations you had with them were off the record and then

write them up for their paper. But Ted was different in that you could talk openly and honestly to him and he would not betray your confidence and let you down. That meant our chats became interesting because I could relax in his one-to-one company. We would talk about football and the people in the game. But we chatted about other things too, including different sports in which we were both fascinated.

"Ted was also covering Formula One for the Daily Mirror *and had some interesting and highly secret stories and revelations to tell about the races and the drivers behind the scenes. I loved it.*

"When we chatted after matches in the players' lounge or wherever he would without fail remember things like the names of our wives and kids – and an attitude like that made a priceless difference. I always enjoyed our conversations, serious or otherwise, opinionated or informative, because he was such good company. He became a big part of the Old Trafford scene, welcomed not only by me but just about all the players. And I picked up on his massive friendship with Bobby Charlton. They were pals from Bobby's younger days at United. Not long after the Munich disaster.

"Football, and the atmosphere off the pitch, was different back in my days. A lot of players then would enjoy going out for lunch or to a local pub or bar for a relaxing pint or two after training. No problem. And we all looked forward to it. I always used to meet with Ted at a restaurant in Manchester, Sam's Chop House or Tom's, two really enjoyable haunts. We used to sit for a couple of hours, noshing, drinking and preparing the column I did with Ted for the Mirror.

"Whether it was in those places or anywhere else with other teammates or friends it was all happy and relaxed and, more often than not, a great laugh. Very, very relaxed. And there was formidable trust. We would tell stories that would trigger other tales and revelations about myself or other players, not just United's lads. We respected Ted for his honesty and judgement in keeping quiet and not publishing some of the riotous stuff that used to be revealed over a relaxing glass or two.

"I genuinely enjoyed doing my column with him, knowing it was getting to millions of readers. Sometimes my stuff was based on my opinion and outlook with both United and England, and Ted would ensure that it was all above board and fascinating to fans and outsiders alike, on the basis of my being a professional footballer and not a writer. It was a real treat because Ted, without fail, always managed to capture my mood and what I wanted to say in a way I would say it if I was chatting over a pint in a pub."

Bobby Charlton, another Manchester United hero, has been a mate forever. We have shared hours and hours at his stylish country mansion in Cheshire, or my then home ten miles away, holidayed together in Britain and abroad, worked here, there and everywhere, and generally revelled in each other's company, frequently in a sponsors' private jet. He says:

"Over more years than I can remember Ted has played a special part in my career and my private life. It has been a unique experience and the biggest imaginable pleasure to be so close to somebody outside the family. We published a couple of books together and I have lost count of the number of times he has featured me in The Mirror *and in magazines and newspapers right around the world. Both my wife Norma and I will be forever grateful that such a friendship is ours to treasure."*

I have a special memory with Bobby. He was sponsored by Ford, and the company PR persisted in loaning him a rather racy and special looking, bright yellow convertible Mustang. I think the prospect of getting behind the wheel of the very noticeable flyer scared the life out of him, and he pleaded with me to drive him and Norma to Anglesey, north Wales, where they planned to weekend on their holiday. I was more than chuffed to oblige!

Nick Ferrari, one of my former bosses on *The Mirror*, then assistant editor, now an internationally famed broadcaster with a massive audience, and a much sought-after writer and national newspaper columnist, says flatteringly:

"For me Ted was the Roger Moore of The Mirror. *Affable, raffish, urbane – and with a glint in the eye that sometimes left you needing sunglasses as it was so bright. He also possessed a singular determination to get the story. If you crossed 007 with a bloodhound with a nose for a tale that was ... and is ... Ted."*

And last, but not least, another former boss, now one of my best pals: Paul Smith, the *Daily Mirror's* ex night news editor and regional editor, now a highly successful businessman and public relations expert and advisor. Smithy recalls our get-togethers:

"I first met Ted when we crossed paths at the Daily Mirror *when it was centred in Holborn. He was a Manchester-based sportswriter and was commuting up and down to London to work at HQ during the week. His sports editor was the enigmatic Arsenal-crazy Keith Fisher whose regime was located just beyond the news reporter area on the second floor. As Night News Editor my news desk looked out right across the News, Sports and Features departments, taking in all the buzz and banter and feverish activity which Ted had joined as an invader from Up North. As a well-respected and talented wordsmith, Ted had a foot in both the sport and news camps, and was well used by both departments. Not only was he a top-class sports reporter covering mainly football and grand prix motor and motorcycle racing, he was also a talented feature writer appearing in just about every section of the paper.*

"Canary Wharf, our new siting, was a shock for all of us. It was such a desolate and remote place with just one pub and a pizza café, a far cry from the fun and bustling bars of Fleet Street, the

(Continued on page 113)

Gallery 2
Mike Hailwood and other sporting heroes

Mike Hailwood.
The Legend!

Guess who – larking about as usual
after yet another big win.

Mike Hailwood at his Oxfordshire mansion home. Note the trumpet and clarinet, both of which he could play, as well as piano and drums.

Mike Hailwood aboard a Mondial winning the 250cc British Championship in 1959 at Oulton Park.

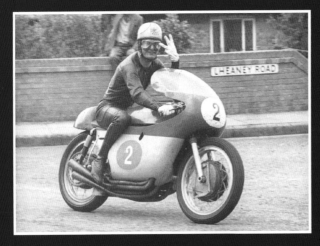

Hailwood indicates he is on three cylinders at the 1963 Junior TT.

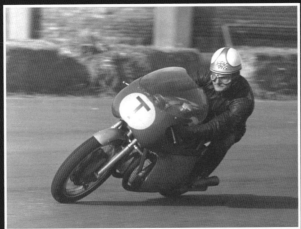

Mike Hailwood in training at Modena.

Ralph Bryans, Hailwood, and Luigi Tavers

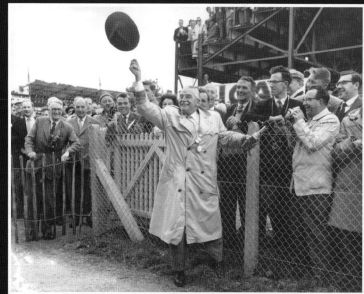

Stan Hailwood celebrates his son's 1961 TT win.

A display of some of Mike Hailwood's vast selection of trophies

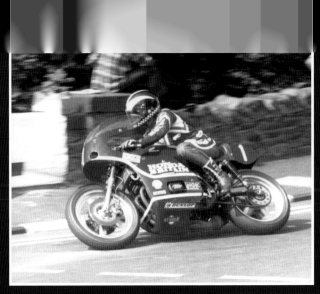

1978. Hailwood's hot rival and world champion Phil Read at full speed in the IOM. Seven times world champion.

Mike Hailwood prior to the Classic TT. (Courtesy Adrian Ashurst)

1978. Mike sitting on the 'Sports Motorcycles' Ducati that swept him to his victorious TT comeback in the F1 race.

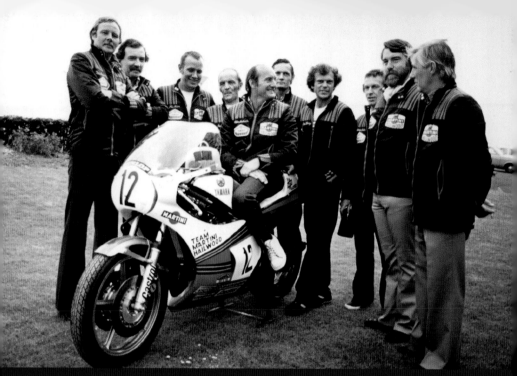

The Martini-Yamaha team behind Mike's comeback. I was the organiser.

Macauley, Hailwood and Alex George after the 1979 Senior won by Mike when I organised and managed his sensational comeback to the Isle of Man TT.

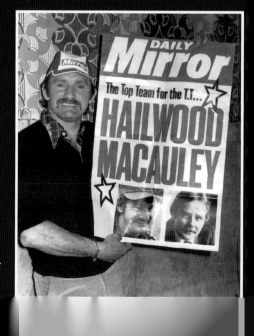

DAILY Mirror
The Top Team for the T.T...
HAILWOOD
MACAULEY

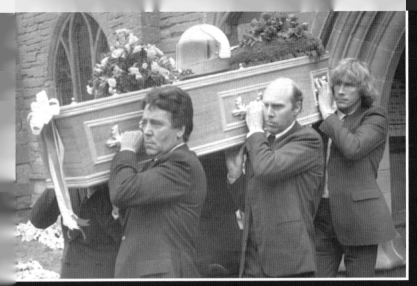

1991. Mike's funeral. Coffin carried by old friends and rivals Geoff Duke, Richard Attwood, James Hunt. I gave the address.

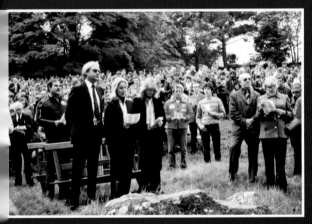

Memorial service for Mike, with Pauline, his widow, 1981, Isle of Man.

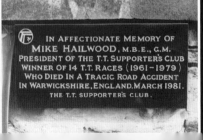

IN AFFECTIONATE MEMORY OF
MIKE HAILWOOD, M.B.E., G.M.
PRESIDENT OF THE T.T. SUPPORTER'S CLUB
WINNER OF 14 T.T. RACES (1961–1979)
WHO DIED IN A TRAGIC ROAD ACCIDENT
IN WARWICKSHIRE, ENGLAND. MARCH 1981.
THE T.T. SUPPORTER'S CLUB.

Plaque in Mike's memory on the Isle of Man TT course.

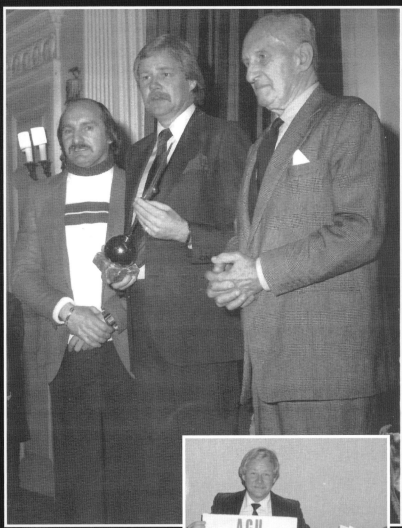

Ted and Mike at the Auto Cycle Union 'Journalist of the Year' presentation at RAC HQ in London, on 15th January 1980. The winner!

At the 'Journalist of the Year' celebration dinner.

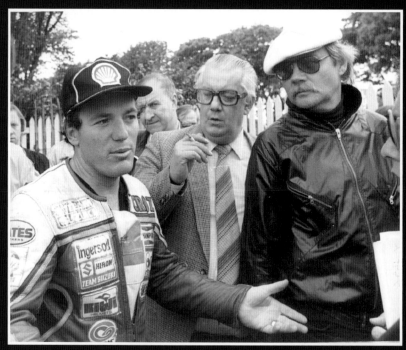

With Graeme Crosby at the IOM TT.
George Turnbull, *The Daily Telegraph* reporter, is our onlooker.

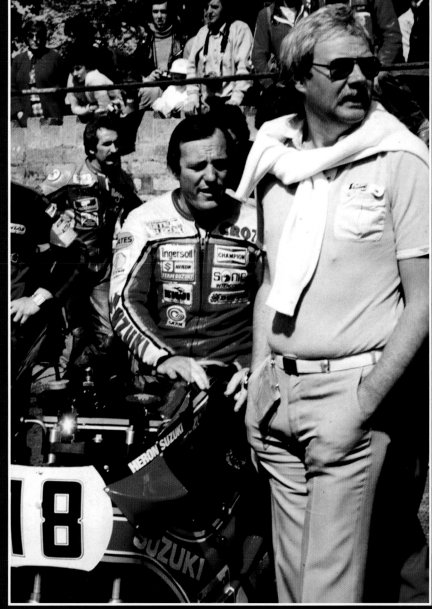

Me with New Zealand ace Graeme Crosby in 1981.

From my days as manager of Rob McElnea, a Great British champion and hero. Note: Ian Ley was my adopted name for my spare time management task!

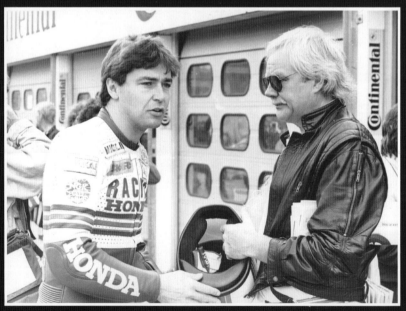

With Roger Burnett, who I managed. He was a superb British champion, and a real gentleman!

Roger Burnett in action.

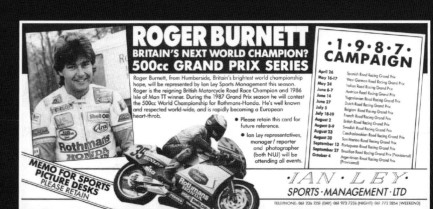

More from my days as a motorcycle racing manager under the
assumed name of Ian Ley.

Giacomo Agostini, the Italian
motorbike grand prix legend.

Giacomo Agostini giving yours
truly a cuddle!

Giacomo Agostini, as usual, surrounded by glamourous girls

My good friend and neighbour Ray Wilkins signed for Paris St Germain in 1987; he was there for 5 months. In this picture Mark Hately and Glen Hoddle, who were both playing for Monaco, played against Paris St Germain. Bobby Robson, the England manager, came to watch them play. (l-r: Ray Wilkins, Bobby Robson, Glenn Hoddle, Mark Hateley.)

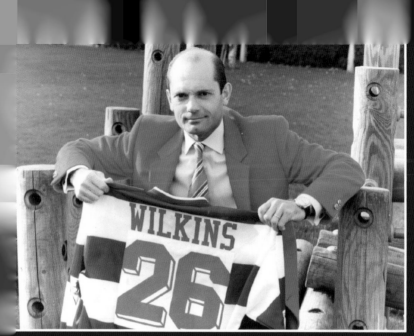

Ray when he signed as a manager at Queens Park Rangers.

With my friend and neighbour, Ray Wilkins, who died tragically

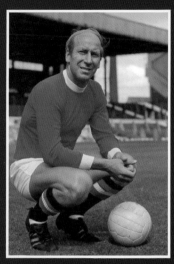

Me with Manchester United legend, and good friend, Sir Matt Busby. Paddy Crerand, team captain, is on the left of photo.

My great friend, Bobby Charlton, the Manchester United and England international legend.

Damon Hill's layout of the British Grand Prix circuit, Silverstone, 1993.

My old friend Bernie Ecclestone, the F1 Grand Prix legend and multi, multi millionaire.

A Christmas card received from my long standing dear friend Bernie Ecclestone.

historic epicentre of journalism. Our new regime running the Mirror under the leadership of David Montgomery, the former editor of Today, *included a ban on alcohol in the office ... unheard of! And lunches out of the office were equally frowned upon with Montgomery favouring that his staff ate at their desks or in the staff canteen. In the sports department Ted was the first to rebel against the new alcohol-free culture. Having been advised by his doctor that he should ditch spirits in favour of a glass or two of red wine after prematurely suffering a surprise heart attack in his thirties Ted took the medical expert at his word and ventured more often into the world of claret at its tastiest.*

"When Café Rouge, a very popular French bistro chain, opened a facility in Canary Wharf, it was manna from heaven for Ted and me, now a committed munchtime companion, and we would slip out to our new watering hole which served a really tasty and value-for-money litre of red in a brown jug. A bite of croque monsieur (ham and cheese toastie) and a couple of jugs of the tasty red stuff enjoyably washed down would keep us fuelled for the afternoon back on duty.

"Café Rouge also had a wonderful tradition of marking the birthdays of their regulars like me and Ted by treating them to a celebratory free bottle of champagne, and we were able to convince unwitting waiters and waitresses, there were regular turnovers of replacement newcomers, that virtually every month one of us would be celebrating their birthday.

"By now I had been appointed the Mirror's Regional Editor, under the leadership of Piers Morgan, and I was responsible for the regional editions Ireland, Wales and Scotland. Our back bench was organised by Craig McKenzie, brother of the legendary Sun *editor Kelvin. It was not long before Craig joined me and Ted for our Café Rouge 'Editorial Meetings and Conferences.' Red wine was not his tipple – he preferred Bacardi and Coke. We recruited Ted to contribute to our regional operation with a weekly feature 'Talking to Macauley' in which he drew on his vast network of sporting*

contacts and stars with Irish backgrounds. Around this time Ted was writing his book 'Grand Prix Men' where each chapter told the story of a key individual associated with F1.

"I wanted him to feature a celebrity and over yet another glass or two of vino in our Café Rouge think-tank, I came up with Chris de Burgh, then a major pop star. Our Irish Mirror *had run an exposé on him having an affair with the family nanny while his wife was in hospital recovering from breaking her neck in a riding accident, and I fancied giving him a favourable reputation rescue of a show in our paper. I phoned Chris, insisted I didn't want to talk about his love life but his fascination with car racing and Formula One, where he was an eager grand prix attender around Europe, and I wanted to give him the chance to air his keenness on the sport. He was hooked by the opportunity – and a fortnight later Ted and I were drinking with him in the green room at Teddington Studios gabbling on about motorsport with Chris, taking a break from recording a TV special, eagerly airing his views on his passion."*

Chapter 12

Dinner with Paul Newman et al

The last of the vintage claret had been poured into Hollywood legend Paul Newman's crystal goblet, and he had patiently interrupted his dinner to sign yet another autograph in the exclusive Arizona restaurant as Christmas carols echoed atmospherically from the neighbouring bell tower. He was seated opposite me with Nigel Mansell on his right, golfer Greg Norman on his left, and celebrity photographer Terry O'Neill making up as fascinating a foursome of the world famous as ever you could possibly imagine, a dream of a scene. Each man was an absolute master of his special and unique art ... acting and film making, motor racing at the very highest strata, and photography at the most demanding and enhanced level – and were all in Phoenix for Mansell's historic Indy Car debut.

Mansell, of course, was in town to drive the 240mph Lola for the first time. Newman, with his good friend, Chicago mega-rich tycoon Carl Haas, were sponsoring the great British driver. Norman, a firm friend of Mansell's and a Gulf of Mexico neighbour, had flown in his private ten-seater jet from Florida, where he was filming, to lend moral support. And O'Neill was there to capture the memorable occasion on film. I was there covering for the *Daily Mirror*. Movie star Newman, once America's Sports Car champion and as formidable challenger in the Le Mans 24 hours clash, was sitting like any other eager race fan in open and unashamed admiration for the Formula

One World Champion, whom he had persuaded to join his IndyCar team after a chance meeting at Chicago airport in the United States. "You know, Nigel," he said, "I would willingly give up any one of the movie awards I have been granted or any one of the Oscar nominations bestowed on me to be able to boast I had been first in just one ... one ... of the Formula One races you have won."

It was a vividly defining moment for the 40-year-old British hero who, in the first place as he told me later, could hardly believe he was sharing a dinner table with a movie star of such towering and universal acclaim, let alone being hailed and placed in a position of envy by a world idol who apparently had everything going for him.

Newman broke off filming in New York to watch Mansell's first Indy Car at the Phoenix Firebird circuit. His journey, and break from filming, he reckoned was well worthwhile when newcomer Nigel absolutely shattered the circuit record inside three debut laps – and raised spontaneous cheers from his back-up crew ... along with whoops from Norman standing precariously on the roof of an engineering truck braving the knifing winter wind.

Later, over dinner, Newman vainly tried to persuade teetotaller Mansell to take a celebratory sip of the vintage claret, encouraged also by Norman, but they were both rebuffed, as Mansell proclaimed: "At my age I have to take all the care and concern I can to keep fit enough to take on all these other truly great racers." At that, 68-year-old Newman, looking a well-kept slim and tidy 50, interrupted with dramatic timing: "Don't I know it Nigel ... don't I know it! Keep up the good work." And he continued: "At your supreme level of fitness, allied to your speed and wonderful ability and daring, you can be Indy Car champion until you are 50 ... and Carl and I would like you to be still racing our cars."

The three-hour dinner only broke up when Nigel announced

he had reached his regular bedtime. It was nine-o-clock! He said his goodbyes and thank-yous and cleared off. The rest of us stayed up talking about him. Well into the next bottle of wonderful claret. It was one of the most memorable occasions of my celebrity filled career. I will never forget Newman or Norman – and they both caught up with me again when they ventured to the UK.

Red Rum and Ginger

My regular and thoroughly rewarding acquaintance with yet another sporting hero ended with a solitary gunshot shortly after dawn in a peaceful rural setting. The 8am blast shattered the stunned silence as it echoed around famous racehorse trainer Ginger McCain's stables, and it brought a heart-breaking and sad finish to the life of his beloved Red Rum, the legendary steeplechaser and the most successful Grand National winner of all time. A vet's gun finally, and mercifully, did what thousands of threatening fences and hurdles had failed to achieve in the unforgettable steeplechaser's heroic career ... it forced the fearless Rummy to surrender, and it left Ginger, his pal and trainer for 23 unforgettable years, in tears, weeping at the memory of one of horse racing's greatest. It was the final hurdle Red Rum could not clear and it closed down the 30-year-old warhorse's latterly troubled life.

It was 1995. Ginger had discovered Rummy lying flat out in his box and, even though, characteristically never willing to give up, he courageously struggled to his feet to nuzzle his trainer – but it was vividly and sadly clear that he was in a desperate situation. He had suffered a heart-attack and was beyond help.

Coincidentally I was going to the stables later that day for an interview with Ginger for the *Daily Mirror*. And I was shocked and sadly disappointed when he told me what had occurred.

He told me: "The old boy was very wobbly. And it was pitiful to see him looking so terribly ill. We were all crying unashamedly. His circulation was failing fast as he deteriorated and it was evident he was not going to survive much longer. We just had to call in the vet."

Ginger and his daughter Joanne, who had grown up with Red Rum and loved him to bits, and his stable staff waited tearfully for the conclusion they feared, but knew the vet could not fail to reach. Ginger told me: "Each one of the yard staff spent a few seconds in Rummy's box saying their own sad goodbyes to the old friend they adored and respected above all the others."

The vet waited, pistol loaded and dreading his upcoming but unavoidable action, as Rummy, ears cocked, listened to the farewell whispers that he did not know were going to be final goodbyes.

"Then just me, Joanne, and the vet John Burgess, knelt beside him," said Ginger. "His head was cradled in my daughter's arms, with those ever curious eyes of his wide open as if he realised what was about to happen. It was a vision so sad it lived on forever in my memory. Then Jo ran from the stable in tears ... no longer capable of being able to withhold her grief. Then it was my turn. I slipped one of his favourite polo mints into his mouth. I had resolved to stay with this amazing friend of many hard-fought and highly successful years ... but I couldn't bear the situation. And to my everlasting regret I chickened out.

"I asked John Burgess if he minded if I departed and he replied, 'No, Ginger, you just pop outside now and leave the necessary to me'. And that's what I did. And at 8 o'clock that fateful unforgettable morning a solitary shot rang out signalling the passing of an era, a legend, beloved companion, the truest friend anybody could ever hope to have."

Ginger, a well established trainer gambled and bought Rummy as a seven-year-old big bay gelding, bred in Ireland and with damaged legs and feet which he helped cure and

strengthen with regular dips in the Irish Sea and beach runs along the Southport shoreline adjoining his stables. His painstaking and patient attention paid off in an historic way. Rummy returned the care shown him by sensationally winning three Grand Nationals in 1973/74/77 and twice coming second in the intervening years, 1975/76, with never a fall in 100 extremely challenging and risky steeplechase races that saw him victorious 73 times. He was buried in the shadow of the winning post on the Aintree track, the scene of his history-making triumphs, a fitting setting. An epitaph there says: "Respect this place, this hallowed ground, a legend hero, his rest has been found, his feet would fly as our spirits soar, he earned our love for ever more."

"Very fitting," said Ginger, "to win the Grand National three times needed an explanation from the Gods. His life and career touched so many in the most wondrous ways and he will be loved forever in peoples' hearts and memories. None more than mine."

My own recollection is of Rummy nuzzling up to me from his box – and nibbling the buttons on my overcoat ...

Chapter 14

Stars from the Emerald Isle

Martin Donnelly had just half a minute to live. Thirty seconds! Look at your watch. Count out the time. It passes quickly, doesn't it? Scarily so ... His grotesquely twisted and broken body, his innards a jumbled jigsaw, his mind spinning, he lay sprawled helplessly closer to death than life after a horrifying headlong crash into the unforgiving barriers at 160mph when he was striving all-out to qualify for the Spanish Grand Prix at Jerez in 1990.

Unconsciously his instinct drove him to fight for breath without an inkling he was quickly edging out of this world. That he is still around to tell the tale is testimony not only to his fighting spirit and courage but, crucially, to the exceptional life-saving, on-the-spot skills of the then Formula One neuro-surgeon Syd Watkins.

The doctor despaired when he knelt beside Donnelly's cruelly battered body. He thought Martin was already dead. He could see that he had been thrown onto the track, still belted in his seat, and with one of his legs hooked over his shoulder. The safety harness marks were imprinted like a tattoo into his flesh as his car exploded on impact. And he had swallowed his tongue.

Belfast-born Martin, who still limps, recalls: "The doc told me later that when he got to me I had about 30 seconds to live. I was suffocating and dying and he had to act sharpish to free

my tongue by going in through my nostrils. Syd pulled me back from the brink when it looked that I was wrecked and a goner. I am glad I was KO'd and didn't know what the hell was happening. But every day since then when I look at my gammy old leg and croak out my sentences I am reminded how lucky I was.

"When I look back and see pictures or videos of me lying on the tarmac looking as if already dead I can't believe my eyes ... until I see the colours of my helmet. Syd Watkins, genius that he was, quickly worked out just what was wrong with me and those 30 seconds were crucial. I would have been six feet under now without his fantastic work. He had a big problem getting to me because the rescue car had to go all around the track and he reckoned it was not fast enough. He argued a fierce case later for a quicker rescue car on race days. I was hurried to hospital and underwent a series of emergency operations. If anything useful arose from my crash it was a revitalising and speeding up of rescue teams and their vehicles."

Donnelly, who had been funded by Dubliner and Grand Prix title dreamer Eddie Jordan, a millionaire, was forced to quit racing aged 34 and fast approaching his peak just as he was on the brink of a breakthrough in FI and its consequent vast riches, a champion in waiting. "It just goes to show how quickly fortunes can change for the worse in FI," he says.

Nowadays, eagerly giving time to Lotus as an advisor, he restlessly spends his hours striving to find an up-and-coming hopeful who could follow his footsteps into FI and achieve what he so sadly missed ... a world Formula One crown. "That would be my dream," he stresses.

In my career I had the absolute pleasure of interviewing, and staying firm friends, with a host of class Irish sportsmen, all of them heroes in one way or another, and all fully and honestly committed to their chosen dedications.

That is why I have singled out some fine examples of

admirable prowess with humble self-regard. The second one is Tony McCoy, the hot-shot jockey, who spurred countless thoroughbred horses, some of which would have been unresponsive also-rans in any other hands, to be first past the winning post to the absolute delight, and financial benefit, of heavily gambling punters and enthusiasts worldwide.

The Belfast man, now Sir Anthony Peter McCoy, OBE, knighted in January 2018, was the first jockey ever to win the BBC's treasured Sports Personality of the Year award in 2010. So what was his background? He rode 4348 winners over jumps and hurdles in the UK and Ireland, with ten firsts on the flat, and was champion jockey for an historic 20 consecutive seasons with major victories in the Grand National, Cheltenham Gold Cup, Queen Mother Championship Chase, and the King George classic. And that despite being the tallest of the top riders at 5ft 10ins, and 11-stone, owing to some serious dieting and exercise every day of his eventful life, and a daily dawn check up on the scales by his bedside.

His daily diet, a strictly monastic regime, comprised a slice of toast for breakfast, maybe with a Mars-Bar or a Kit-Kat chocolate bar washed down with half a cup of iced water for a treat.

"I even dreamt about waking up lighter than I was when I went to bed," he confessed ...

He once confided to me: "There could be 100,000 racegoers jammed right up against the rails, yelling and waving and screaming, but honest to God. I never saw or heard them when I was concentrating on getting my mount first across the line.

"As the rider of big time horses I was so switched on to the crucial job in hand and getting the best out of the horse and being the winner, I never allowed my mind to go ego-tripping, to wander or lose absolute concentration for a split second. It was vital not to get side-tracked or affected by the atmosphere, even in front of the massive enthusiastic crowds at places like

Aintree and be trapped into relaxing and unguarded and letting thousands of people down. It was too easy to fall off and finish up under a mass of potential killer hooves."

He regularly harvested £2m a season in prize money – with an £85-a-ride fee and 7.5 per cent of the winnings.

I leave the last word to one of his firmest admirers, Martin Pipe, a trainer with a magic touch, who told me: "It was his incredible single-mindedness and dedication that set him apart and ensured he was the best. I was delighted that he rode for me – he was so tremendously energetic and focused. That is why he was a true champion."

It would be neglectfully remiss of me if I exited the Emerald Isle without paying tribute to yet another one of its historic stars. Okay, he is one of the oldest and dearest friends, but notwithstanding any likely accusation of favouritism, and with not the merest trace of shame, I cite ex Formula One driver and towering personality Eddie Irvine, the playboy and fun-loving character with whom I spent many (late) hours in stopovers in the farthest reaches of the globe. Nowadays he is multi-millionaire investor with a portfolio of at least 40 properties around the world, said to be fifth richest being in Northern Ireland with £160m in readies.

His greatest F1 season was the 1991 campaign when he registered four wins for Scuderia Ferrari, and was runner-up in the final title countdown, a serious challenger to Mika Hakkinen for the top spot. Soon after he quit the GP scene. Altogether, on top of those victories, he clinched 26 podiums ... with NO fastest laps and NO pole positions. But "Irv the Swerve" – "Fast Eddie" – was always a flamboyant treat to watch, a fans favourite. And mine ...

"Playboy ... me?" he quizzed frowningly over yet another vodka and tonic as we sat in a Monaco bar. "Not me, but I did enjoy life to the full," he grinned.

Chapter 15

Schumacher

Inevitably, by delving deep into my incident-filled career with its never-ending stream of sagas, thrills, nerve-wracking recalls, and friendships with sporting heroes and showbiz legends there will always be an inescapable moment or two of sadness and heartbreak, one of them being my association with grand prix great Michael Schumacher.

Currently laid up, with no revelation as to his condition either from family or friends, following the bizarre accident that overturned his life. After risking his life racing at 200-plus-mph and surviving spectacular crashes galore, he fell cruelly foul of a freak life-changing setback when he tripped and tumbled in a skiing accident travelling at not too much over fast walking pace and suffered, I am told, brain damage. He was placed in an induced coma until 2014. It was a tragedy beyond belief ... Schuey, one of the fittest of drivers with a daily four-hour gymnasium regime and a rigorous lifestyle with severe rationing and avoidance of booze and fattening foods.

I had known him, and been strong friends with him, since our initial meeting in 1991. I interviewed him for my newspaper at the 1992 Belgian Grand Prix when he snatched his first victory. I watched that historic breakthrough victory – and viewed his last triumph in China in 2006. Between times we cemented a relationship.

But let me go back to happier days, with a re-run of my column for a Dubai magazine:

The withering look when I ask Michael Schumacher what are his hopes and dreams for Formula One suddenly bridges a gap of 19 years. This is the second time I have posed such a question. The previous occasion was in 1991 when we were sitting in sponsor Eddie Jordan's motorhome before Schumacher's F1 debut in the Belgian GP. Then the German was a penniless hopeful, only a kart and junior class racer, but talented enough to stir Dubliner Jordan's fascination and provoke thoughts on his chances for a crack at the big time. This time around, in Barcelona for a test session ahead of his return to F1 after a three-year-lay off, it is his comeback, and the cold-eyed and unblinking stare is identical, I recall, to the one that gripped me nearly two decades ago. The terse answer is, too: "I don't deal in hopes or dreams. Only realities," he says.

His Bahrain GP opener tomorrow, and the 18 Grands Prix to follow, may be electrifying for race fans, but to their 41-year-old hero it is merely another convenient stepping-stone back to the business of striding proudly onto the top steps of the world's F1 podiums. Schumacher is no longer the hard-up kid in a home-made kart. He has around Dh5 billion in the bank, a beautiful and devoted wife, Corinna, and two children. Gina-Maria, 12, and nine-year-old Mick, all living in the mind-boggling splendour of a vast villa on the banks of a swanky Swiss lake. "I do not want for anything," he stresses, "except to continue being a winner and a world champion again. That is why I decided to come back to F1. I should never have left it when I did. But, honestly, I had grown bored because it seemed there was nothing left for me to achieve. My batteries had run flat." His numbers game, fashioned from redoubtable skill and courage around F1's concrete cauldrons, sped him into the record books as the most successful Grand Prix driver of all time. He was a history maker. The day he turned his back on his rip-roaring career he had amassed 91 wins, 43 second places,

20 thirds, 68 pole positions, 76 fastest laps and seven world titles in 249 outings with Jordan, Benetton and finally Ferrari, his dream team.

The consensus is that his spell on the side-lines, watching the action from pit lane and operating restlessly as an ambassador for Ferrari, only served to fire up an eagerness to get back behind the wheel to mix it with the eager beavers of F1. He has honed himself with day-long sessions in the gym and again hit a peak of fitness, back to his race day weight and slender shape, and recovered from a frightening neck injury sustained in a motorbike race crash during his brief foray onto two wheels early last year. Unsurprisingly he had offered so much promise as a bike-ace, showing enough ability to be given test outings on James Toseland's Honda, plus Ducati and Yamaha factory superbikes, that Carlo Fiorani, the Honda-Europe boss, tried his hardest to tempt him to take up the sport full time. No chance ... With £2million bid for his services why he did not take up the offer has never been disclosed. He simply explained: "No thank you. I am counting myself out." Whether Corinna had a say, with her natural worries and concerns after he had hurt himself so seriously in a crash that would scupper his first bid for an F1 comeback with Ferrari, is a moot and ponderable point. I would not mind betting she had her say ...

Schumacher is hailed and harangued in equal measure as a hero and a villain because of his unyielding ferocity on track, which is both despised and admired according to your preference. But he does not care and he harbours no desire to change his attitude. "I race the way I race," is his response to the critics. "If people don't like it ... tough ... there is nothing I can or want do to. My need has always been to be a winner, to be the champion, to be the best. For my own satisfaction, nobody else's. I know I am going to be given a hard time by the likes of Jenson Button, Lewis Hamilton, Fernando Alonso, Seb Vettel and even my own team-mate Nico Rosberg. But that will only serve to make me even more motivated."

Among F1 fans Schuey has often been regarded as a pantomime

villain. Amongst his peers, emotions have sometimes run stronger. Perhaps, most famously, there was an incident during the 1994 Australian GP when Schumacher was forced to retire after clipping his car on a side wall. As he steered back on to the track he collided, whether it was deliberate or not is the question, with Damon Hill's Williams, ending the British driver's race. As a result of the hit neither driver scored a point – and Schumacher became world champion. Hill's succinct comment was: "There are two things that set Michael Schumacher apart from the rest of us drivers in Formula One: his sheer talent and his attitude. I am full of admiration for the former ... but the latter leaves me stone cold." Three years later Schumacher was caught in reprise of the incident at the European Grand Prix ... this time with Jacques Villeneuve. This time his move backfired – and Schuey was left stranded in the gravel as Villeneuve completed the race. An investigation by the stewards resulted in Schumacher being stripped of his second place in the championship.

At Spa, Belgium, in 1998 it was Scotsman David Coulthard in the firing line, Schumacher accused him of trying to kill him! To underline his ruthlessness, Schumacher's brother Ralf, also a driver, was left with the choice of either crashing or dropping back when his sibling blocked him as he attempted to overtake in the 2001 European confrontation. Add to that Schumacher's win-at-all-costs stance when he was in Monaco, the year he quit, he deliberately dumped his scarlet Ferrari on the racing line on a crucial corner in qualifying to purposely block his challengers and wreck their timed runs.

But then the ruthless Schumacher has always pushed himself towards the pole position. Let's go back to his childhood and developing of his lifelong competitive spirit ... He was born in Hürth, a city in northern Germany, and his father Rolf, a bricklayer, first modified four-year-old Michael's pedal car with a small petrol engine. After he crashed it into a lamp post, his parents decided he would be better served at the local karting club with his dad

(Continued on page 145)

Gallery 3
On film sets, on holiday and at home

On the set of *The Last Remake of Beau Geste* in 1977, with, left to right, Peter Ustinov, Marty Feldman and Roy Kinnear.

With Trevor Howard in Ireland. I also fell victim to his incredible boozing ability. And we were daily dinner partners for a whole week, with drinks being sent over to us from his admiring fellow diners.

Chatting to TV and movie star Cherie Lunghi on the set of her 1981 movie *Excalibur*. She starred in more than 50 TV shows with live theatre and film appearances in between.

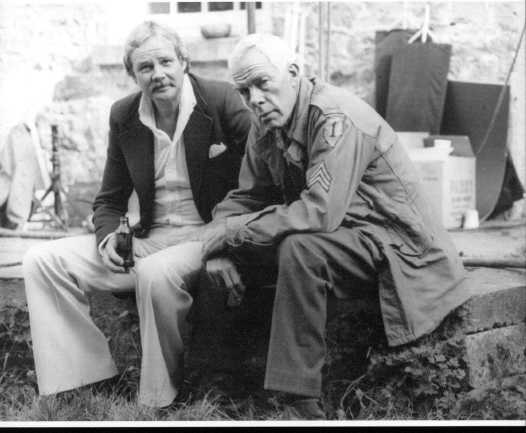

With Lee Marvin, Hollywood megastar, on location, when I was
The Mirror's movie/showbiz writer. The movie *The Big Red
One*, was being filmed in the Dublin area. We spent a week
together, but owing to Lee's famed 'indulgence' little of the time is
remembered! However, the hangovers are never to be forgotten …

Talking to Michael Caine at the filming of *Educating Rita* in Ireland, 1983.

With Peter Bowles on the set of *The Irish RM*, a TV series from 1983/85.

Ted with Dublin-born Irish actor Brian Murray, also at the filming of the TV series *The Irish RM* in 1983.

My old friend Billy Connolly and me, top right in trilby and saluting with my left hand, with friends aboard a tank!

A couple of love-birds playing in *The Big Knife* at Watford's Palace Theatre. Ian McShane and Gwendolyn Humble became my firm friends and our holiday companions.

"No, love, I'm sorry but I daren't give you my phone number – my wife Delia would kill me."

Guess who – playing the 'baddie'!

RENAULT Renault 'Fly-drive' - Goodwood, April 2005

Me on a promotional air trip for Renault.

QUEEN MARY 2
Captain's Table
9 August 2015

Partying aboard Queen Mary 2 en route to New York from
Southampton.

Delia and I at the Captain's cocktail party on the Queen Mary 2.

Paul Smith and his late wife Debbie. Paul, a *Daily Mirror* editorial executive, was my boss for 40 years, and is now one of my best friends! Delia is the laughing lady on the left!!!

Ted about to mount a "Taxi" camel on a visit to Dubai for the United Emirates grand prix.

Delia relaxing in Dubai 2001 on holiday.

Me and Delia in Budapest before the Hungarian Grand Prix.

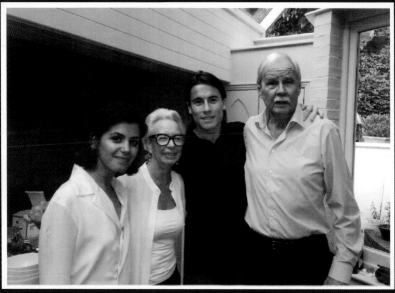

Me, with James Toseland and his wife, world star singer Katie Melua, and my wife Delia, before lunch cooked by Dee at our home.

Me in Hong Kong en route to Japan for the Grand Prix.

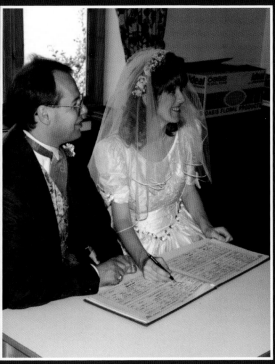

My son Iain and
wife Pam on their
wedding day.

On my way to my daughter Kerris' wedding.

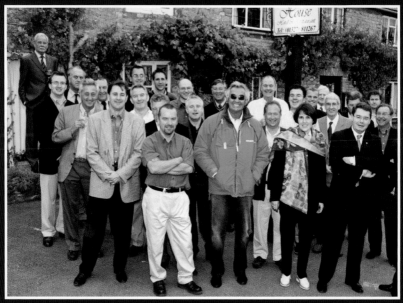

Which one is Ted? Media get together with Flavio Briatore, the
Italian businessman, at the Silverstone GP, 2002. (I am top left,
grey suited, standing alone.)

Spike, my boxer dog pal on guard at the Macauley dwelling. I
heard him bark only once in the eight years we were together, it
surprised him so much, he fell off his rocking chair.

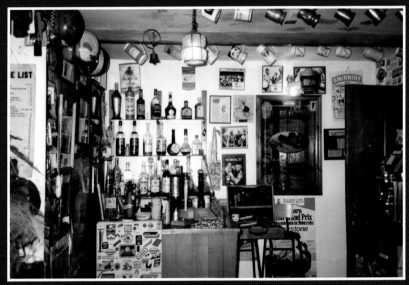

My bar packed with booze and souvenirs – regulars included
Bobby Charlton, George Best, Francis Lee, and actors Ian
McShane and Lee Marvin.

An extension of the bar at home: souvenir stacked from decades of
sports coverage all around the world.

Me again, at home in my memory-filled studio.

This trophy was a gift from Mike Hailwood. The biggest trophy in
his collection, from his flurry in Formula 2.

building his kart from spare parts. When a German regulation requiring kart racers to be at least 14 years old threatened to put the brakes on his budding career, 12-year-old Michael applied to Luxembourg where the legal age requirement was lower. By the 1980s he was working his way up the Formula racing path towards their top class and he landed his first F1 drive with Jordan-Ford in 1991, his ability recognised and encouraged by the astute Irishman-Dubliner Eddie Jordan, who was ambitious to be a team owner on the front ranks.

"Whatever people think of me, good or bad, is their own business and I don't care. I have always done what is necessary to be a winner. And I will never change. I can't. It's the way I am. My nature. People can take it or leave it ..."

David Coulthard, who later became a TV commentator, said at the time "As he developed, some people accused him of making the sport dirtier – but that territory, to my mind, was already occupied by Ayrton Senna. I guess it doesn't matter what people, drivers and spectators alike believe about race ethics – but it had to be recognised that both Ayrton and Michael became fantastic champions."

F1 supremo Bernie Ecclestone developed a unique, massively firm friendship and unashamed admiration for Schuey, and when he secretly revealed to Bernie he was intent on making his return the race boss confided to me: "I cannot wait. And I bet all those other guys on the grid who want to give him a hard time feel the same way. The same goes for the 650 million people all over the world who are fixated to the F1 scene. The drivers will all want to show him who's the boss and the best – but I know Michael will be in no mood to allow that to happen. He has a fabulous reputation to uphold and defend, and he is going to give some of those youngsters on the grid lessons they will never forget."

Ross Brawn, a talented mastermind behind all Schumacher's haul of top honours when they were Ferrari partners, but switched to Mercedes, closely monitored his pre-season mood, and he said:

"He has lost nothing. I reckon he will be back as if he has never left. And he will be just as fast. His fitness is impressive, almost scary – and he has recovered completely that motorbike crash neck injury. His passion and motivation, allied to a natural ability and courage beyond measure, is incredible. If we can put together a car to match his genius he will be one hell of a problem for his rivals. Over the past few weeks I have watched him closely and I have seen it all come back to him. I honestly believe we will see a spectacular repeat of all the rare qualities of the Schumacher we grew to respect when he was at his peak. I am just ever so proud to be his partner once again."

Wicked rumours suggested that Michael had originally walked out on Ferrari and a £25M (DH138M) a year salary because the Italian giants had signed fast developing Kimi Räikkönen, the dour and deadpan but very quick Finn. "That is complete and utter nonsense. Absolute rubbish," was the unequivocal retort from Jean Todt the former Ferrari chief.

"Anybody who speculated that Michael quit us and retired because he was afraid of being beaten by his own team-mate is just plain stupid. Michael was not, is not and will not ever be afraid or wary of anybody. And we wish him all the very best when he makes his return ... even if it is with our rivals. We know he will be hard to beat."

It would be remiss of me not to include Schuey's colourful personal manager Willi Weber in this summary of the record-breaking champ. We are together in a Monaco setting and Michael, sitting close to his guiding light, is listening intently, saying nothing, as Weber who brilliantly masterminded the driver's switch from also-rans Benetton to Ferrari opines: "On the Grand Prix grid, they are all great drivers. Otherwise they would not be there. They all have ambition. They all risk their lives. They dream – and they pray for luck. To be the champion, the best in the world, is to win the lottery. Michael goes out

every race and buys all the tickets. And it has paid him back hundreds of times not only to his own and his family's benefit – but to all the spectators all over the world who have been privileged to watch a genius at work. Aren't we all lucky?"

Brief encounters

I would like to make a brief addition to include a batch of valued memories without stretching the references much beyond somewhat skeletal outlines of some of the glamorous names who have featured so strongly in my colourful career from my earliest days with the now defunct northern *Daily Despatch*, the *Daily* and *Sunday Express*, *The Daily* and *Sunday Mirror*, *Manchester Evening News*, *Liverpool Echo* and a host of glossy magazines worldwide. It would be negligently remiss of me if I passed up the chance.

They are all outside my well-featured legendary figures elsewhere in my book like Michael Caine, Bobby Charlton, Ray Wilkins, Mike Hailwood, George Best, Ringo Starr and Bernie Ecclestone.

I shall open with the beady-eyed threateningly low voiced American tough guy actor Lee Van Cleef, one of Hollywood's greatest movie villains, who died of a heart attack in 1989. He had starred in hit films like *The Good, the Bad and The Ugly* and *For a Few Dollars More*. We met on a movie set in Ireland, and he took me to a pub that had become his favourite haunt. And he was charm personified – even giggling when I asked him how he had lost a finger. "It was in a bar fight when a rough guy out to prove himself thought I was like my movie characters in real life – and he wanted to put me down," was his revelation.

Irish actor Richard Harris was another hell raiser – on and off

the screen. He died in London in 2002 aged 72. He had starred in *This Sporting Life* among many other movies. "I don't seem to attract troublemakers," said the burly, wide-shouldered and bent-nosed hard man ready for a scrap any time anybody wanted to give him a tough time."

Robert Mitchum, mega movie star, stage actor, director, poet, author, singer and composer, was a modest and absolute charmer, another pub companion when he was starring in the romantic drama *Ryan's Daughter*, in Ireland, in 1970. He died in 2002 at the age of 79.

Not long after my Mitchum meeting I spent a few boozy days with his *Ryan's Daughter* co-star Trevor Howard, who, as we sat emptying our third bottle of vino in a snazzy restaurant with its whispering and hushed poshed-up diners, beckoned me towards his face when he whispered then roared: "Come here. Hear me out. I do get B-L-O-O-D-Y N-O-I-S-Y, from time to time." As well as *Brief Encounter* he featured in dozens of top films and was awarded honours galore including Baftas and Emmys. He died in 1988, aged 74.

Londoner Peter Ustinov, a vast winner of awards, like Golden Globes and Emmys, was yet another bright, intelligent and funny actor whom I met on my familiar stamping ground of Ardmore Studios in Dublin. He was 82 when he died in Switzerland, his adopted home, in 2004.

Then there was former actor then director Richard Attenborough, who had my hair trimmed to a sparse back and sides, and fitted me up with a commando's fighting gear, so I could make the briefest – scariest – appearance as an extra, running across and battlefield and dodging bloody terrifying explosions in *A Bridge Too Far*. Over dinner, charmer Attenborough constantly cited Anthony Hopkins – later to be knighted – with high praise. He had directed the Welshman in five films. And he told me: "He is the greatest actor of our generation. A star."

And speaking of Anthony Hopkins: it was 1988 when we had our first get-together at a pub beside Lake Coniston. He was not quite the world mega star he quickly grew to be on the basis of his impressive acting ability – and, honestly, I had never heard of him. But I most certainly had heard of – and knew extremely well – the heroic character he was playing: Donald Campbell, the world record setting speed merchant on land and water, nicknamed 'The Skipper.'

I spent about a month living above a cake shop in Coniston, covering Campbell's bid to break the world water speed record at 300mph in Bluebird 7, a jet-engined hydroplane. And we grew to be regular diners and drinkers together in the local pubs and restaurants escaping the chill January blasts as Campbell and his entourage waited for a calmer break so he could aim at his scary target. Not that he worried too much, he had broken eight absolute speed records and was accustomed to the risk. And he was as calm and collected as can be when we set off for the lake for what turned out to be the disastrous and fateful accident that brought the 46-year-old's life to a spectacular and abrupt end, with the Bluebird flying off the water at about 250mph and plunging to the depths of the lake. I could not believe my eyes as I watched from the bank and witnessed the most dramatic and horrifying scene of my life. It was January 4, 1967. His body was not recovered until 2001.

Tony Hopkins, starring as Campbell in the 90-minute TV movie *Across the Lake* listened intently. And he sympathised: "That must have been one awful shock. Now you are here for a re-run. And that I guess will provoke a mental reaction and fire up the memory of that moment when Bluebird flew off the water. I feel privileged to be playing such a fantastic man. Thank you for your recollection."

Chapter 17

Epilogue

The complexities of recall, from my news and movie feature interruptions to my beloved sports and F1 coverage for the *Daily Mirror,* are far too vast to venture too deeply into that hectic area of my journalistic career, exciting and exhausting as it all was to serve five million readers a day. Suffice to say, however, it will be fitting to wind up this Macauley outlet and feedback with a visit to my fast-fading Memory Lane.

Flights on Concorde to New York, first-class sailings aboard Queen Mary 2 with dinners at the captain's table, stayovers at the ritziest hotels on the planet, private yacht cruises and get-togethers with actors and mega film stars like Clint Eastwood, Paul Newman, Trevor Howard, Lee Marvin, Peter Bowles, Michael Caine, Peter Ustinov, and Ringo Starr when I toured for six weeks with the Beatles, and Rolling Stones leader Mick Jagger in Tokyo and the Isle of Man when uppity Sir Dudley Cunliffe-Owen, director of the prom-front hotel where the Stones were staying, whispered to me "They are all awfully smelly bounders." They were rather certainly aromatic having just arrived from Los Angeles, after an elongated and exhausting US tour, on an overnight flight to London's Heathrow and an immediate transfer to Ronaldsway, the IOM's airport.

I covered the Six-Day War between Egypt and Israel, risking life and limb to sail up the Suez Canal aboard a (costly) private yacht, with the skipper/owner, to view the action and was jolly

relieved to survive and fly home to safety thanks to an RAF facility.

Then there was the 'Bodies on the Moor' drama with weeks spent on the chilly and rainy Pennines, not too far from my home, as the remains of the murdered children were unearthed from the killers' burial mounds – targets of the misguided twosome, sadistic Ian Brady and the wickedly evil Myra Hindley.

Another extremely sad event was the Stockport air crash when, in June 1967, with just six miles to go to landing safely the BMA flight, a victim of fuel starvation, crashed marginally short of the town centre with 72 deaths from 82 passengers.

And the 'Cod Wars' in Iceland, when I had to hire costly trawlers to take me to the showdown scenes between British boats and Icelandic protectors in the roughest of seas when, one time, a giant wave swept over my bouncing and bobbing trawler when I was ... stupidly ... on the open deck and drenched me and my very, and I mean VERY, expensive blue suede Harrods-bought overcoat which I had to wear for the next week.

Ireland and The Troubles was another risky journalistic jaunt, with my disguising myself crazily, stupidly, in dark glasses and a black suede jacket to look like an IRA man to attend on the front row at the Londonderry church ceremony of the burial of 13 members of the rebels shot dead by SAS marksmen on what was dubbed 'Bloody Sunday', to write a *Mirror* scoop.

There were plenty of light-hearted breaks, too. Namely a modelling commitment for the exclusive Kendal Milne superstore on posh Deansgate, central Manchester's social and shopping hub. Poses in a three-piece yellow suit and black bowler beside a Rolls-Royce and its chauffeur, then Kung Fu pyjamas, swimming trunks and a Macauley clan plaid kilt, knee high to my skinny legs, under the guidance and really

close attention of a rather, shall we say, too-attentive older woman fashion writer.

I was also recruited as a bit part player in a wartime movie, uniformed and with the severest crop of hair imaginable, alongside mega-star Sean Connery, playing a tank commander, with whom I lunched so enjoyably, for an entertaining week.

The globe's newspapers and magazines must have been overflowing with my endless supply of words, features and references to my firm friend Mike Hailwood, the greatest motorcycle race champion of all time, still to this day a prominently fond image in my life. That memory is helped whenever I go into my loo. There, placed on a shelf under the window in the throne room by the mischievous great man, is a giant trophy, probably the biggest he was ever awarded. "Do me a favour. Among all the other silverware, I have no room for it," he said, "so I'd like you to have it as a thank you for all your work and sleepless nights on my behalf."

And there it will remain ... as does Stanley Michael Bailey Hailwood in my mind's eye. An inspiration ...

Chapter 18
Postscript

I shall finish with a hand-written letter from my old Houldsworth school headmaster, AH Norburn, penned around half-a-century ago as I prepared to leave the Cheshire establishment. Having reached this stage in my lifetime with a fascinating and absorbing career, taking in just about every emotion possible, with testing, scary and wondrous times to mingle with joyous experiences and meet-ups with world renowned figures, see if you agree with his forecast which I unearthed by accident from piles of fading pictures and yellowing cuttings in a long forgotten suitcase in my attic. I'm saying nothing!

The postscript goes:

Edward Macauley is a most reliable and trustworthy youth. He is earnest, keen and intelligent. And I know that he has the making in him of a first-class craftsman. He is better in English and art than other subjects. He can be depended upon to give of his best and to be sociable and co-operative. I can with pleasure recommend him to a position of trust.

What, dear reader, do you think?

Also by Ted Macauley:

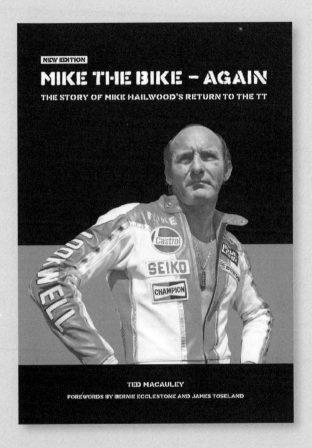

An inside look behind the scenes at the top-secret planning, build-up, and spectacular success of Mike Hailwood's amazing comeback in 1978, 20 years after his debut at the age of 18. Written by his manager and friend, Ted Macauley, it is also a tribute to a remarkable man.

ISBN: 978-1-787113-13-8
Paperback • 21x14.8cm • 112 pages • 40 pictures

For more information and price details, visit our website at www.veloce.co.uk • email: info@veloce.co.uk • Tel: +44(0)1305 260068

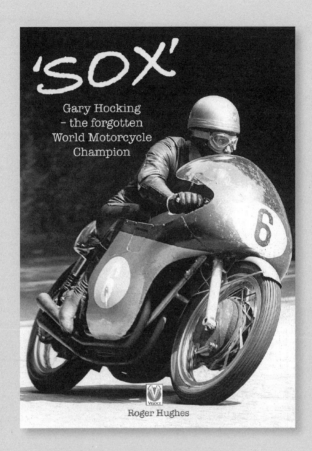

Motorcycling social history, as seen from the saddle. Bill Snelling's entertaining autobiography recounts a lifetime spent at the heart of British motorcycle sport, and living on the Isle of Man.

ISBN: 978-1-787115-81-1
Paperback • 21x14.8cm • 160 pages • 202 pictures

For more information and price details, visit our website at www.veloce.co.uk • email: info@veloce.co.uk • Tel: +44(0)1305 260068

Index